The Lewis Chessmen

and the enigma of the hoard

Neil Stratford

THE BRITISH MUSEUM PRESS

Published by The British Museum Press
A division of The British Museum Company Ltd
46 Bloomsbury Street, London WCIB 3QQ

First published 1997
Reprinted with revisions 2001

A catalogue record for this book is available from the
British Library

ISBN 0 7141 0587 2

Designed and typeset by James Shurmer

Printed in Slovenia by Korotan

Maps and line drawings by Jim Farrant

Photography by Pete Stringer, British Museum
Photographic Service (reproduced by courtesy of the
Trustees of the British Museum), except for the following:
pl. 5 The British Library; pl. 2 Society of Antiquaries of
London; pl. 3 author's own; pl. 4 (Charles Kirkpatrick
Sharpe by C. K. Sharpe) Scottish National Portrait Gallery;
pl. 38 Germanisches Nationalmuseum Nürnberg; pls 39 and
40 Louvre; pl. 41 Bibliothèque Nationale; pl. 42 Sotheby's
Picture Library; pl. 43 Board of Trustees of the Victoria and
Albert Museum; pl. 45 Fratelli Manzotti, Piacenza;
pls 51, 52 and 53 National Museum, Copenhagen;
pl. 54 Riksantikvaren, Trondheim; pl. 55 Kulturen, Lund;
pl. 55 National Museum of Iceland (photo. Ivar
Brynjólfsson); pl. 57 Louvre; pl. 59 author's own.

Acknowledgements

Fionna Ashmore; Giulia Bartrum; Michael Borrie;
S. G. E. Bowman; David Caldwell; Peter Carelli (Lund);
Caroline Cartwright; Marjorie Caygill; Mary Clapinson;
Anna Contadini; Danielle Gaborit-Chopin; I. C. Freestone;
David Gaimster; John Goodall; Alexander Heslop;
Christopher Hohler; Erla Hohler; M. S. Humphrey;
Dafydd Kidd; Andrew Kitchener; Deirdre Le Faye;
Niels-Knud Liebgott; Fritze Lindahl; Rosalind Marshall;
Chris McLees; A. P. Middleton; Bernard Nurse; Else Roesdahl;
Ljubov Smirnova; Michael Spearman; C. P. Stapleton;
Gudrún Sveinbjarnardóttir; Janet Wallace; Rachel Ward;
Leslie Webster; Christopher Wright; Susan Youngs

Contents

Chapter 1
The Enigma of the Hoard *page* 4

Chapter 2
The Lewis Figures 12

Chapter 3
Chess and Chessmen 31

Chapter 4
The Raw Materials 39

Chapter 5
The Lewis Chessmen and Scandinavia 41

Chapter 6
The Lewis Chessmen and Romanesque 48
Europe

Appendix A
Accounts of the discovery of the Lewis 50
Hoard

Appendix B
Technical observations 54

Notes 56

Bibliography 60

Concordance of Numbers 63

1 The Enigma of the Hoard

On 17 October 1831, Frederic Madden, Assistant Keeper of Manuscripts in the British Museum, made the following entry in his journal:[1]

'Sir Walter Scott came at two o'clock and stayed about an hour with me. I had the pleasure of looking over with him a set of very curious and ancient chessmen brought to the Museum this morning for sale, by a dealer from Edinburgh named Forrest. They were discovered in a sand-bank on the west coast of Scotland, and are the most curious specimens of art I ever remember to have seen. Mr. Harris mentioned them to me when last in London but I did not expect to have held them in my own hands. There are 82 pieces of different descriptions, all made (apparently) of the teeth of the sea-horse, or morse, of which number 48 are the superior chess-men – forming parts of four or five sets, but none of them perfect *per se*, although two complete sets can be selected from them. Besides these there are the pawns, which are plain, and a set of draughts- or table-men. An ivory buckle also was discovered with them. These pieces are apparently of the 12th century, and of fine workmanship. As for the costume of the pieces (King, Queen, Bishop, Knight and a warder or armed figure, in lieu of a Castle) in regard to the armour, episcopal dress, they will require some research and as the whole probably will be engraved in the Archaeologia, I shall say nothing more of them here. The price asked for them is 100 gns. If our Trustees do not purchase them, I fear the sets will be broken up and sold separately, which will be a great pity.'

Sir Walter Scott in his journal on the same day wrote:[2]

'The morning beautiful to-day. I go to look after the transcripts in the Museum and leave a card on a set of chess men thrown up by the sea on the Coast of Scotland which were offered to sale for £100.'

The presence of the author of *Waverley* in Bloomsbury on that very day was a remarkable coincidence. Through his poems and novels Scott exercised a major influence, particularly in France and Germany, on the early revival of interest in the Middle Ages. But this has never disguised his lack of a scientific understanding of the period, and in the same journal entry he goes on to date the Lewis chessmen to the fourteenth century! What is more surprising is that he had evidently not been shown the

chessmen during their period in Edinburgh, an episode to which we will return.

The unexpected arrival of the eighty-two pieces of the Lewis hoard at the British Museum was followed by their purchase between November 1831 and January 1832. After haggling over the price, the Edinburgh dealer, T. A. Forrest, received from the Trustees of the British Museum the sum of 80 guineas, negotiated with some difficulty by the Keeper of Antiquities, Edward Hawkins.[3] Hawkins indeed saw the extraordinary importance of the chessmen. 'There are not in the Museum any objects so interesting to a native Antiquary as the objects now offered to the Trustees', Hawkins wrote in his report to the Trustees; such a comment must be judged against the climate of the time, when there was in many quarters a more than reluctance to form a national collection of post-Roman British Antiquities.[4] Behind Hawkins' shoulder stood Frederic Madden (pl. 1), who was the true instigator of the purchase. Assistant Keeper of Manuscripts, Madden was a remarkable palaeographer and scholar of early vernacular literature, who happened also to be an enthusiast for board-games.[5] The accuracy of his judgement as to the date and significance of the Lewis hoard will become apparent in the following pages. As to his promised

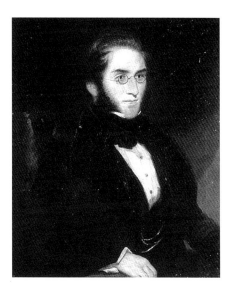

1. Sir Frederic Madden (1801–73), by William Drummond. Oil on canvas, about 1837.

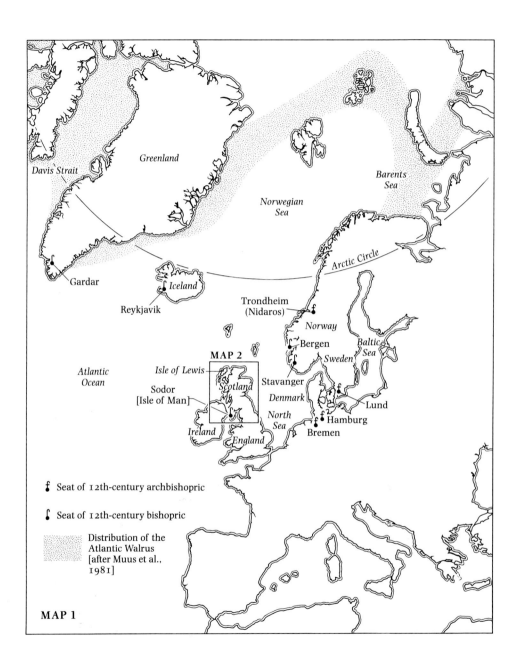

Davis Strait

Greenland

Barents
Sea

Norwegian
Sea

Arctic Circle

Gardar

Iceland

Reykjavik

Trondheim
(Nidaros)

Norway

Bergen

Baltic
Sea

Atlantic
Ocean

Isle of Lewis

MAP 2

Sweden

Stavanger

Scotland

Sodor
[Isle of Man]

Denmark

Lund

North
Sea

Hamburg

Ireland

England

Bremen

𝔣 Seat of 12th-century archbishopric

𝔠 Seat of 12th-century bishopric

Distribution of the
Atlantic Walrus
[after Muus et al.,
1981]

MAP 1

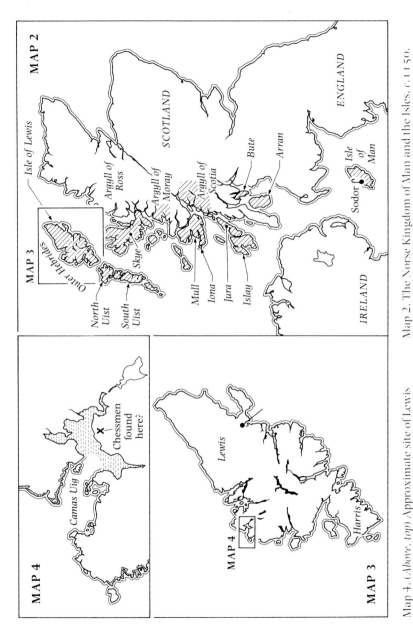

MAP 2

Isle of Lewis

Outer Hebrides

MAP 3

North
Uist

South
Uist

Skye

Mull

Iona

Jura

Islay

Argyll of
Ross

Argyll of
Moray

Argyll of
Scotia

SCOTLAND

Bute

Arran

Sodor

Isle
of
Man

ENGLAND

IRELAND

MAP 4

Camas Uig

X Chessmen
found
here?

Lewis

Harris

MAP 4

MAP 3

Map 4. (*Above, top*) Approximate site of Lewis
Chessmen find in 1831.

Map 3. (*Above*) The Isle of Lewis.

Map 2. The Norse Kingdom of Man and the Isles, c. 1150.

////// Diocese of Sodor and Man

7

Archaeologia article, it appeared in 1832,[6] and still reads today as a *tour-de-force* of research (pl. 2).

How did Forrest acquire the eighty-two pieces and what do we know of the find? Various references to the discovery of the hoard are reproduced in Appendix A. They read with greater or lesser conviction, include conflicts of fact or circumstance, and produce in the reader a mounting sense of the power of legend over historical truth. Out of all this what can be deduced?

The hoard was found before 11 April 1831. By this date it had reached Edinburgh where it was exhibited to the Society of Antiquaries of Scotland.[7] There is no argument that the find-spot was in Uig, on the west coast of the Isle of Lewis in the Outer Hebrides (maps – pp. 6–7). If we may discount the legends of nuns, shipwrecks, murdered sailors and hangings

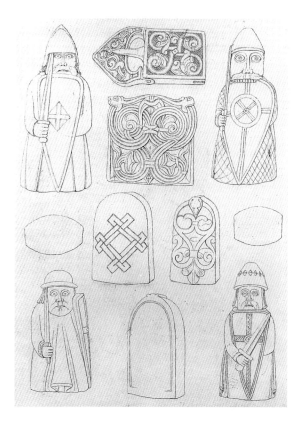

2. Drawings of the Lewis Chessmen, by Frederic Madden, engraved for *Archaeologia* in 1832 (Society of Antiquaries of London).

3. The sand-dunes and south shore of Uig Bay, Isle of Lewis.

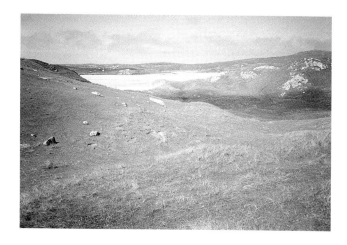

in Stornoway, and if the intervention of a cow or a peasant in the process of discovery cannot be proved, it is nevertheless likely that the hoard was found in a sand-dune, possibly within a small drystone chamber with ashes on its floor, sometime in the spring of 1831.[8] The area known locally as the place of the find is on the south shore of Uig Bay, in the Ardroil Machair, among the sand-dunes of a gully running up from the sea, several hundred yards from the bay, in a region populated from an early period.[9] It seems unlikely that the sea would ever have reached such a point. The extreme fragility of the surfaces and broad seams or cracks which can be found on a number of the pieces cannot be accounted for by submersion in water. On the other hand many of the surfaces point to the burrowing of tiny termites such as are common in sand. There is no evidence for the intervention of sea-water, only of general damp and perhaps major fluctuations of temperature. Some pieces are in excellent condition, others severely damaged by climate or damp, but we do not know why there is such a marked disparity (see Appendix B).[10]

The first owner seems to have been Malcolm Macleod of Penny Donald, who sold the hoard, or at least most of it through Roderick Ryrie (or Ririe or Pirie), a Stornoway merchant, to Forrest in Edinburgh for £30. The Edinburgh story of the hoard is not well documented.[11] A scheme for the Society of Antiquaries of Scotland to acquire a group of pieces for its Museum and to pay for the purchase by allotting other pieces

to contributing Fellows was not put into action, so Forrest tried his luck with Madden at the British Museum. In the meantime – and unbeknownst to Madden – ten pieces had been quietly purchased by the Scottish antiquary, genealogist and artist, Charles Kirkpatrick Sharpe (pl. 4), who was as it so happens a lifelong friend of Sir Walter Scott. Sharpe later acquired a single extra piece, a bishop, from the Lewis itself. At the Edinburgh sale of his collection in June 1851, the eleven chessmen were bought for £105 by another enthusiastic antiquary and collector, Lord Londesborough, bidding against the Scottish Antiquaries and the British Museum.[12]

Londesborough died in 1860 but his collection was only dispersed in 1888. Sir Augustus Wollaston Franks, the Keeper of British and Medieval Antiquities at the British Museum, co-operated once again with the Scottish Antiquaries and arranged for them to purchase all eleven pieces at Christie's for 100 guineas, less than half the expected price.[13] When the joint bid had been unsuccessful twenty years earlier in 1851, Franks had tried for three pieces, the Scottish Antiquaries for the remaining eight; Franks referred to the 'bad behaviour' of Forrest at the auction, where the dealer had acted for Lord Londesborough. But the matter goes further back in time, for Forrest had concealed from the British Museum in 1831 the fact that he had already disposed of some pieces to Sharpe, and Madden set great store by keeping the hoard together and preventing its dispersal into small lots.[14]

Thus, there are today ninety-three known pieces: eighty-two in the British Museum, eleven in Edinburgh in the National Museums of Scotland. It is entirely possible that one or more pieces are still in private hands and have never been recognised.

That having been said, we know of eight kings, eight queens, sixteen bishops, fifteen knights, twelve rooks in the form of 'warders', nineteen pawns, fourteen plain disks for a game (*Tabula*), the ancestor of modern draughts, and one belt-buckle. They are all carved from walrus-ivory, except possibly for a few which may or may not be from whale's teeth.[15] Edinburgh has two kings, three queens, three bishops, one knight and two warders. To make the reader's life easier, the numbering system adopted here is based on Dalton's 1909 British Museum Ivory Catalogue (see Bibliography) and on the 1892 Edinburgh catalogue of the National

Museum of Antiquities of Scotland; a concordance of these and other numberings is on pp. 63–4.

Given the opaque history of the find, it is fruitless to speculate on whether there could originally have been a number of complete chess-sets. Nor do we know whether the hoard was originally deposited loose, or in a box or bag. Certain facts are, however, established. From the survivors it is possible to make up most of four complete sets; they would lack as many as forty-four pawns but only one knight and four warders. Some pieces are unfinished in very minor respects, but this is not in the least unusual with Romanesque sculpture in ivory, stone and wood, where applied colours often supplemented the finishing details. This could well have been the case here. Thus, eight of the pieces and several pawns were recorded in 1832 by Madden as stained red, to distinguish them from the white pieces (see Appendix B). The pieces must therefore have been considered ready for play. None of this adds up to evidence for the buried *débris* of an *in situ* walrus-ivory workshop. It is more likely, as Michael Taylor suggested, that the hoard was part of the stock of a merchant, lost in circumstances which we shall never know.[16] No more can at present be said.

4. Charles Kirkpatrick Sharpe (1781?–1851), by himself. Wash drawing, after a portrait by Thomas Fraser (Scottish National Portrait Gallery).

2 The Lewis Figures

The kings are seated on thrones, a sheathed sword held across the knees (pls 5–11). The queens are also seated. They rest head on right hand, which is supported by the left hand except where some of them hold a horn (pls 12–17). Out of the sixteen surviving bishops, there are seven who are seated (pls 18–19); the others stand (pls 20, 22). They wear mitres, the points of the mitre forwards, and they carry a crozier either in both hands, or with one hand holding a book or blessing. They are vested in tunicle and cope, or in full pontificals with tunicle, dalmatic, stole and chasuble. The back and sides of the thrones are richly decorated, some with fleshy, densely packed foliage scrolls, of which a few are in-habited by beasts or have beast-head terminals; some of the foliage panels are divided halfway

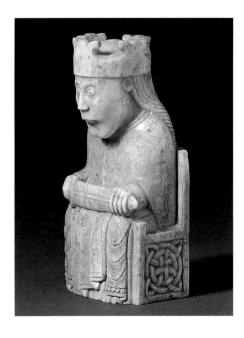

5. King (Iv. Cat. 79).

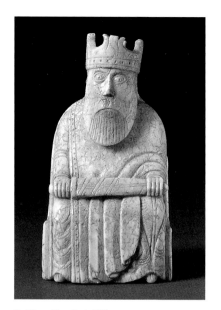

6. King (Iv. Cat. 78).

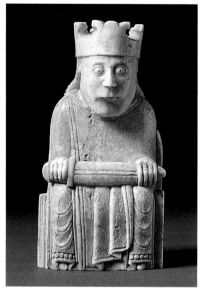

7. King (Iv. Cat. 79).

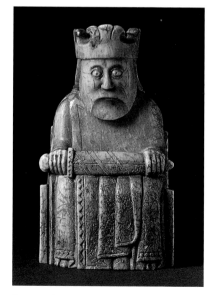

8. King (NS 19).

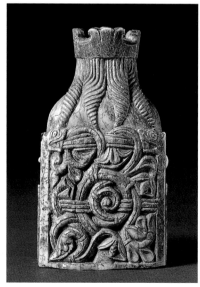

9. King (NS 19).

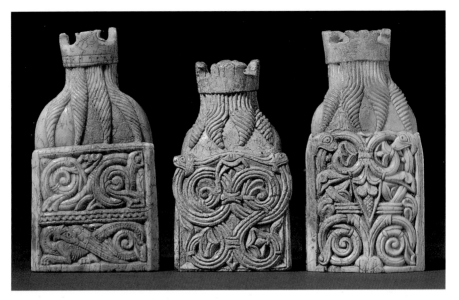

10. Kings (Iv. Cat. 78, 80, 79).

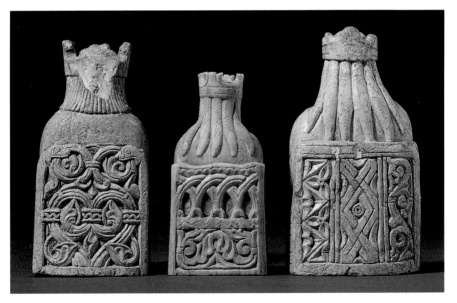

11. Kings (Iv. Cat. 81, 83, 82).

up by a decorated or plain horizontal bar (pls 10, 19). A variety of geometric and interlace ornaments complements the foliage scrollwork, with a repertoire that includes chevron and intersecting arcading (pl. 11, 14). The knights ride their horses, more ponies than horses, with bridle and stirrups, armed with a spear in the right hand, a sheathed sword on the left side, kite-shaped shield on the left shoulder and helmet. The helmets are usually pointed, some with nasals and ear-flaps, but a few are rounded, with or without a rim (pls 23–6). The shields are decorated with a range of simple geometric or foliage patterns, which suggest an embryonic tendency towards a distinguishing heraldry (p. 29). As for the warders, they stand holding a sword in the right hand, a shield against their left side. Their helmets and shields are similar to those of the knights, and they are dressed in full-length surcoats, a few mailed (pls 27–31); one helmet (pl. 30) has an unusual two-tier shape with a flat top and a band of indentations halfway up. Some of the warders bite the tops of their shields (pl. 31). The pawns are for the most part small octagonal obelisks, with rounded tops, although one has a small knob on top (pl. 34). Three others are again octagonal but flatter, with concave angles (pl. 33). There is also a larger pawn with grooved edges and a trefoil knob on top (pl. 32), and there are two flat pawns like *stelae*, decorated front and back with interlace (pl. 32, p.28) and foliage scrolls. The counters are all plain solid disks, but many of them have one, two or three circles incised with a compass just inside the border; the point for the compass is still visible in the centre (pl.35). The belt-buckle (pl. 36) is made up of a rectangular plate of walrus-ivory, its bottom edge pierced by four holes and a groove for attachment to a leather or textile strap; the short, pointed tongue and the mitre-shaped loop of the buckle are held to the plate by a strip of wire; the front of the plate and buckle are engraved with elegant foliage scrolls. There is an evident unity of stylistic approach as between the foliage on the pawn (pl. 32), the buckle (pl. 36) and the backs of some of the thrones (p. 27), so that we can confidently accept the hoard as the product of a single workshop.

Every piece is different. Variations are played on a narrow range of motifs known to the workshop, although it is clear that a far greater freedom was enjoyed in the carving of the foliage than in rendering the figures which are more stereotyped. Thus, it is instructive to compare

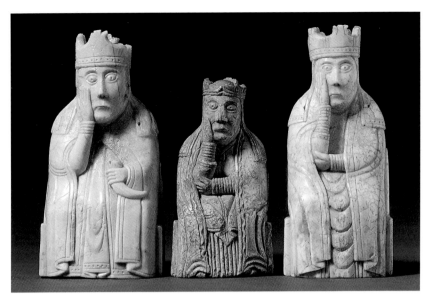

12. Queens (Iv. Cat. 84, 87, 88).

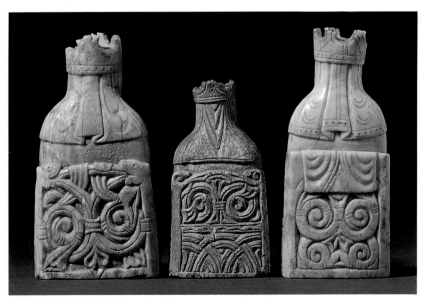

13. Queens (lv. Cat. 84, 87, 88).

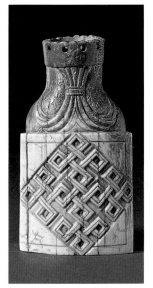
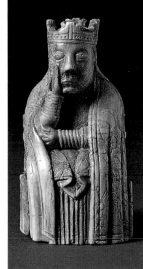
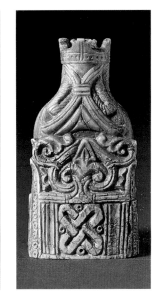

14. Queen (NS 21). 15. Queen (NS 22). 16. Queen (NS 22).

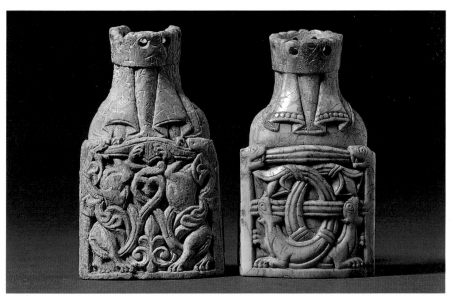

17. Queens (Iv. Cat. 85, 86).

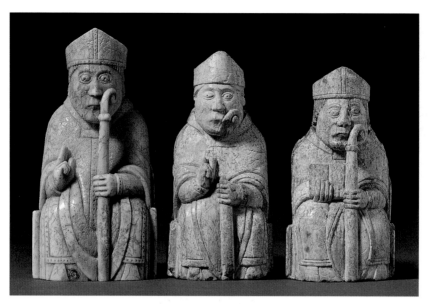

18. Bishops (Iv. Cat. 90, 91, 92).

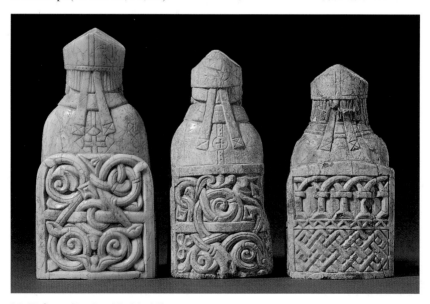

19. Bishops (Iv. Cat. 90, 91, 92).

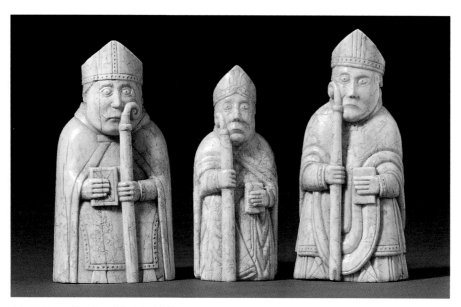

20. Bishops (Iv. Cat. 98, 99, 100).

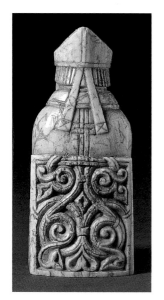

21. Bishop (NS 24).

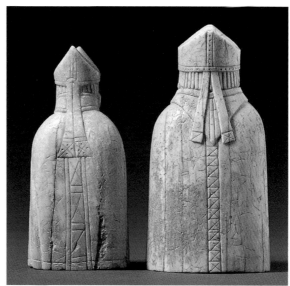

22. Bishops (Iv. Cat. 94, 98).

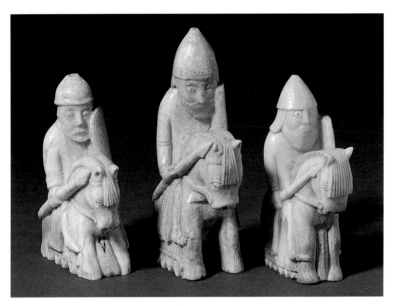

23. Knights (Iv. Cat. 103, 112, 107).

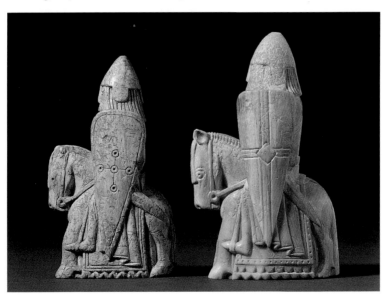

24. Knights (Iv. Cat. 111, 114).

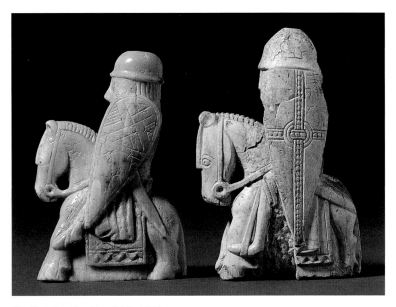

25. Knights (Iv. Cat. 102, 105).

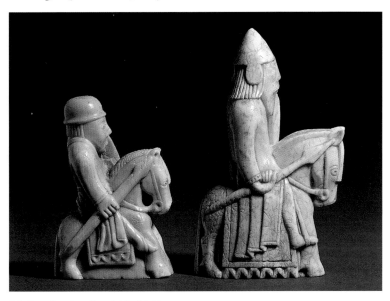

26. Knights (Iv. Cat. 102, 113).

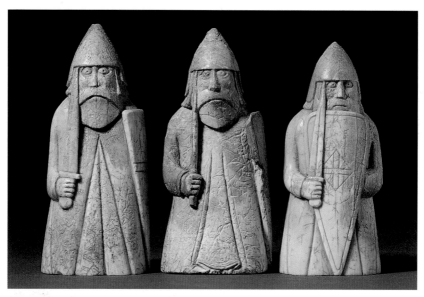

27. Warders (Iv. Cat. 116, 117, 118).

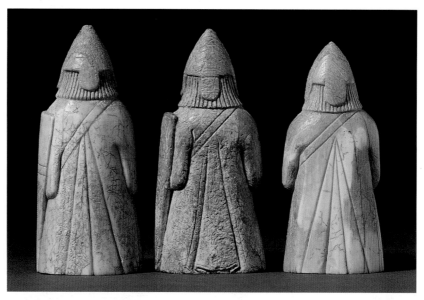

28. Warders (Iv. Cat. 116, 117, 118).

two bishops (pl. 18, left): both are seated and make a gesture of blessing, with a crozier in the left hand. The variations of detail are minor in both pose and costume. When the backs of the two bishops are examined (pl. 19, left), they are much more boldly carved but again similar, with comparable interlacing foliage. Here, within a known and comparatively limited repertoire of forms, the carver or carvers never slavishly repeat a model – or pattern-book – but play variations on each form according to taste. The foliage displays a high level of invention; the ornament is sophisticated, whereas the figures reappear as types. Yet these stocky figures with simple draperies are imbued with a colossal energy, as if the bodies have emerged from the mass of the tusk fully armed, the product of the attack of the carver on the block cut from the long slender curving tusk.

There were of course two controlling factors. The first was the size of the walrus-tusk. More will be said about walrus-tusks, their appearance and

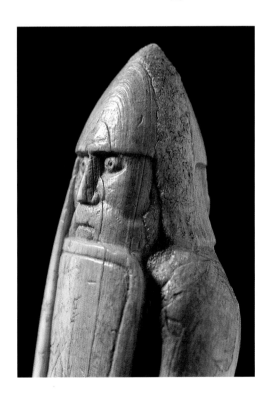

29. Warder (Iv. Cat. 118). The secondary dentine of the walrus-tusk is visible on the side of the helmet.

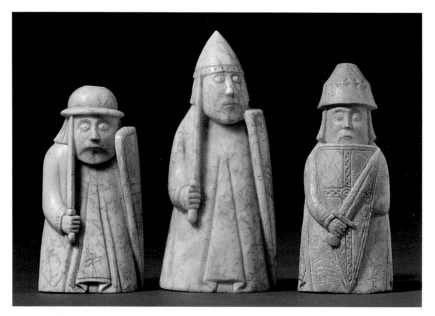

30. Warders (Iv. Cat. 122, 119, 121).

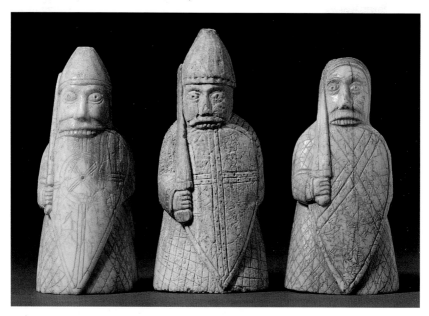

31. Warders (Iv. Cat. 124, 123, 125).

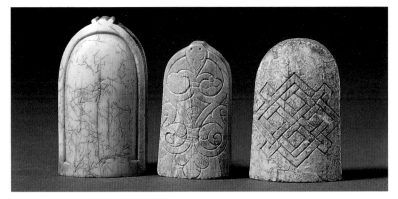

32. Pawns (Iv. Cat. 126, 127, 128).

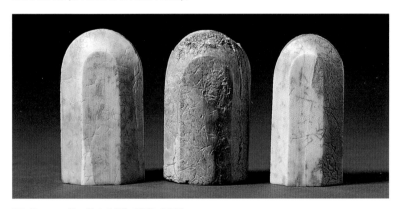

33. Pawns (Iv. Cat. 129, 130, 131).

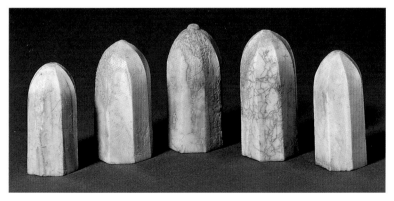

34. Five pawns (from Iv. Cat. 132–44).

their availability. Here it is sufficient to record that the tusks can attain almost 1 m in length but never more than about 10 cm maximum in width.[17] The widest of the Lewis chessmen are only 5.5 cm across, the highest is 10.3 cm (see Appendix B). The other limiting factor was the secondary dentine that fills the pulp cavity of the tusk, an area which the sculptor must do his best to avoid or to accommodate within the silhouette of the figure, if the lustrous surface of the white 'ivory' is to be seen to advantage (note for instance how the secondary dentine is visible on the outer surfaces of the head of the warder (pl. 29). One further

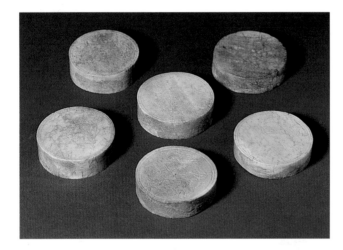

35. Six 'tablemen' (from Iv. Cat. 146–59).

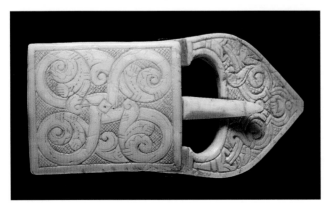

36. Belt-buckle (Iv. Cat. 145).

KINGS

78 79 80

81 82 83

NS 19 NS20

QUEENS

84 85 86

87 88 NS 21

NS22 NS 23

27

BISHOPS

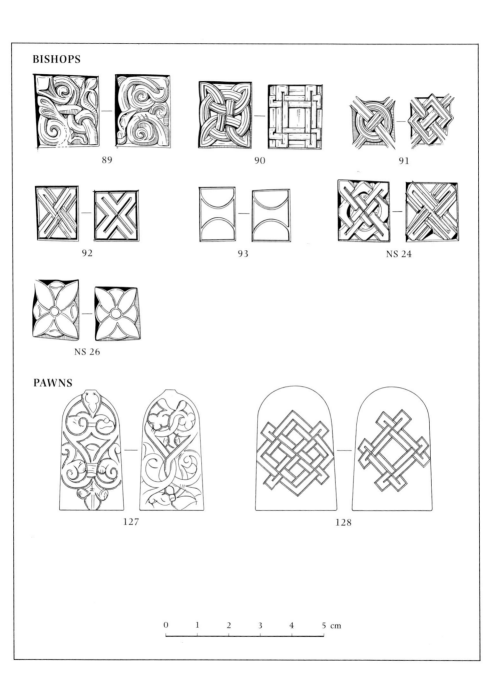

89

90

91

92

93

NS 24

NS 26

PAWNS

127

128

0 1 2 3 4 5 cm

KNIGHTS

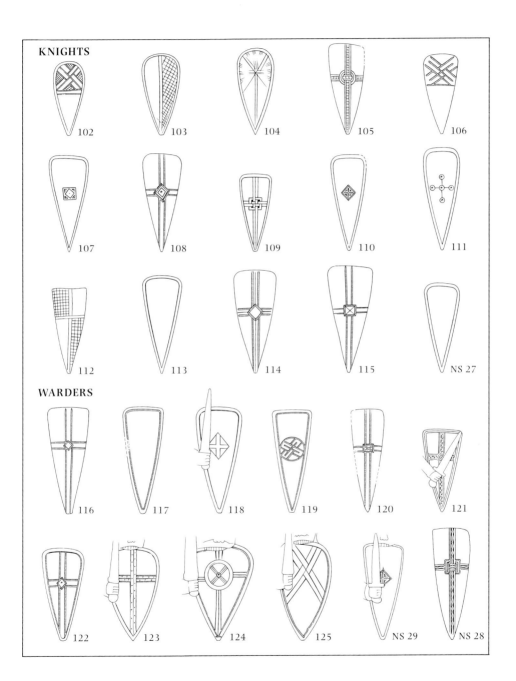

102 103 104 105 106

107 108 109 110 111

112 113 114 115 NS 27

WARDERS

116 117 118 119 120 121

122 123 124 125 NS 29 NS 28

29

restriction was exercised on the carver. Necessity dictated the compactness of the forms: projections would easily snap off, and these were pieces to be played with, not for display.[18]

The bold, simplified figures, uncluttered by delicate details, epitomise what since the nineteenth century we have come to know for better or worse as 'the Romanesque style'. What is more, the fascination which these miniature sculptures have continued to exercise over several generations is warrant enough that they are by no means 'provincial' but major works of art, superbly designed and speaking directly to our sensibilities, small-scale but monumental. To judge them historically as products of the twelfth century we must now turn briefly to the earlier history of chess and chessmen.

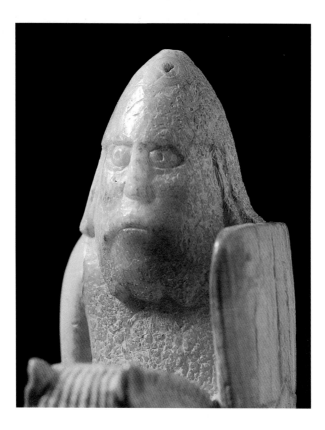

37. Knight
(Iv. Cat. 114).
The piece is
unfinished.

38. (*Opposite*)
Bone chessmen:
(from left) two
Kings or Queens;
Knight; 'Bishop'
(elephant); Rook
(chariot). Western
European or
Islamic, 8th to
10th century (?)
(Nürnberg, GNM).

3 Chess and Chessmen

Chess in its modern form came into being in the second half of the fifteenth century with the extended moves allocated to queen and bishop, but versions of the game are of course very much older. The history of chess can be traced through texts back to the sixth century AD in India, thence into Persia and the Islamic and Byzantine worlds.[19] As to the introduction of chess into northern Europe, the claims of Islam, with its presence on the Spanish peninsula, and of Byzantium are equally balanced. The earliest datable reference to chess in northern Europe occurs in the Einsiedeln verses of the late tenth century, in a monastic context within the diocese of Konstanz.[20] By the end of the eleventh century, the game was established throughout Europe in aristocratic circles, from Spain and Italy to Scandinavia, the German lands and the British Isles.

In the Islamic world chess was usually played with abstract pieces, probably on the basis of the non-Koranic interdict on images.[21] The pieces could be carved from elephant-ivory, bone, stone, rock-crystal or some other precious material, or they could be ceramic. The abstract forms grew ultimately out of the function of each piece as part of the army; chess is after all a war-game. Some of these forms are illustrated in pl. 38. They were taken over lock, stock and barrel by Europe. Indeed many early medieval chessmen found in Europe are indistinguishable from their

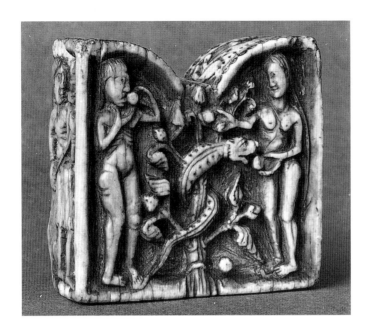

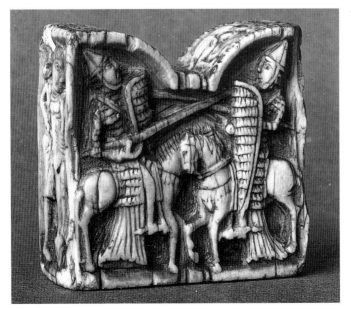

39 and 40. (*Above and left*) Elephant-ivory Rook: The Fall of Man; Knights in Combat. French (?), about 1150 (Louvre).

Islamic counterparts. Some may even be imports from Islam. Such forms continued to exert an influence throughout the Middle Ages, sometimes even being applied to figured pieces, as in the case of a twelfth-century rook in the Louvre, which is carved with episodes from the Genesis story of Adam and Eve, and on the reverse with two knights in combat (pls 39–40); and yet this piece still retains the two-pronged silhouette of the original Indian war-chariot.[22]

Alongside this prevalent abstract tradition, another tradition co-existed, even during the earliest centuries of the game, that of elaborately rendered pieces which displayed their full military or courtly function. The celebrated series of elephant-ivory chessmen from Saint-Denis and traditionally associated with Charlemagne, are now attributed with a greater or lesser degree of certainty to a south Italian workshop in the later eleventh century. They represent the best surviving European examples of this early tradition of the anthropomorphic chessman (pl. 41). The Lewis pieces are heirs to this tradition, even if they simplify it. What is more, by the second half of the twelfth century, the date when they were carved, simplified anthropomorphic chessmen from other parts of Europe (pl. 42) prove that they were by no means unique.[23] We have probably lost the vast majority of such pieces. Indeed the sheer size of the Lewis hoard implies that there must have been a real demand for this type of chessman.

We know that by the second half of the twelfth century two-coloured boards had long been in use. For instance, there is a famous early twelfth-century floor mosaic in the sanctuary of the abbey church of San Savino at Piacenza, which shows a board entirely appropriate to modern chess (pl. 45).[24] If the Lewis chessmen were to be placed on such a board, each square would have to be at least 10.3 x 10.3 cm, which if we then assume a 'modern' sixteen-a-side game implies a board no less than 82 cm across. Since some of the pieces were, on Madden's say-so, stained red, the intended board could also have been red and white. Well-preserved examples of Romanesque 'draughtsmen' will serve to illustrate the appearance of two-coloured sets (pl. 44).[25]

As to the later medieval history of chess, a review would take us beyond the boundaries of the world inhabited by the Lewis chessmen, to didactic and moralising treatises on the game, and to a courtly ambiance in which chess became an exemplar for Courtly Love, the Vices and Virtues and

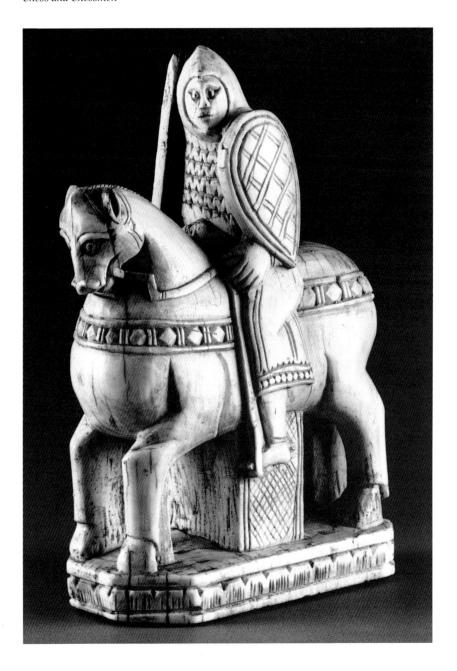

other allegories (pl. 43).²⁶ The battle of chess of the 'Feudal Period' was slowly transmogrified into a chivalrous or allegorical commentary.

What is the position of the Lewis chessmen when we take into account the early development of the forms of the different pieces? The king remains a king, but the queen (or *fers*) has evolved out of the general or minister, the Arabic vizir or wise man. The queens are shown in repose, chin on hand in a gesture reminiscent of the attendant St Joseph beside the crib at Christ's Nativity. Some of them hold horns, which may be either money-horns or drinking-horns. The elephant of Indian chess (Arabic *al-fil*) is here a fully-vested bishop, representing the western Christian church, and it is important to note that the Lewis bishops have no known predecessors among surviving European chessmen. If there can be no question of considering them as 'first' (we have no doubt lost ninety-nine per cent of their Romanesque counterparts), it is nevertheless probable that the representation of a bishop as a chesspiece was a Romanesque 'invention';

41. (*Opposite*) Elephant-ivory Knight, from the 'Charlemagne set'. South Italian, late 11th century (?) (Bibiliothèque Nationale).

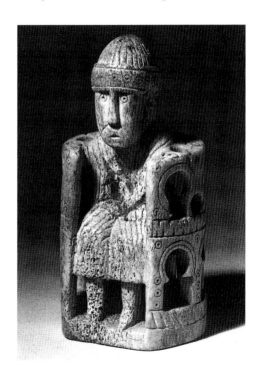

42. (*Right*) Bone or antler King, found at Dorf Langenbogen, near Mansfeld (Saxony). German, about 1150 (ex-von Hirsch coll.).

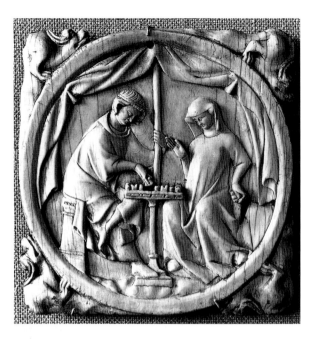

43. (*Left*) Elephant-ivory mirror-back: a game of chess. Paris, about 1300 (V&A).

45. (*Opposite*) Floor-mosaic: a game of chess. Piacenza, San Savino, early 12th century.

44. (*Below*) Elephant-ivory counters for 'tables'. Cologne, about 1200 (British Museum).

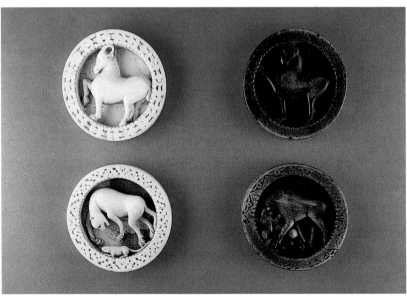

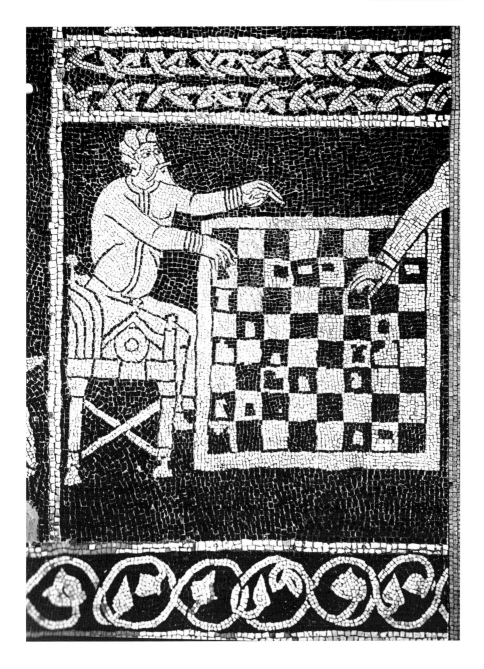

46. Whale's bone chessmen, found at Witchampton (Dorset). Late 11th century.

we will return to this point. As for the knights, their pointed helmets, kite-shaped shields and other details of their arms and armour belong securely in the eleventh-twelfth centuries; they have often been compared to the armies of the Bayeux Tapestry (after 1066 – before 1082). They are also significant in that their shields are decorated with a simple language of patterns (pl. 29), which belong to the moment in the twelfth century when the knight was just beginning to adopt heraldry as a distinguishing device; the earliest securely datable shield of arms (*lioncels rampant or on an azure ground*) is carried by Geoffrey Plantagenet, Count of Anjou, on the enamel plaque from his tomb monument in Le Mans Cathedral; he died on 7 September 1151 and his epitaph is mentioned in 1160.[27] The Indian war-chariot, as we have already seen, became in European chess a two-pronged rook (Arabic *rukh*, chariot) (pls 38, 39–40). The tower or castle was gradually introduced as part of that move towards making chess a courtly pastime, which was a reflection of the taste of the thirteenth and fourteenth centuries, but it did not become widespread until the end of the Middle Ages. But the Lewis rooks are 'warders', standing foot-soldiers, warding the margins of the board, a most unusual form. Indeed this is the military origin of the pawns, whose name in English derives from the medieval Latin *pedo*, a foot-soldier. The forms of the Lewis pawns are more traditional. For instance, the octagonal obelisks (pl. 34) are exactly prefigured among the chesspieces from Witchampton Manor (Dorset), probably of late eleventh-century date (pl. 46, right).[28]

4 The Raw Materials

The Lewis chessmen were apparently carved from two materials, the vast majority from walrus-tusks, a very few from whale's teeth (see Appendix B). Imports of elephant ivory from Africa and India were incredibly rare in northern Europe during the centuries from Late Antiquity until the middle of the thirteenth century. The economic or political causes for this drying up of the old ivory trade remain totally obscure, but dry up it certainly did. Instead other tusks, teeth, horns and even animal bones were exploited to try to achieve the same effect. A place of honour among these 'substitutes' was given to the tusks of the huge marine mammal, the Atlantic walrus (*Odobenus rosmarus rosmarus*). The tusks could exceptionally grow to 1 m

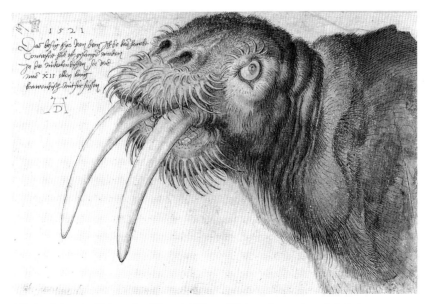

47. An Atlantic Walrus, by Albrecht Dürer. Watercolour, signed, dated 1521 (British Museum).

in length and 10 cm in width at the base (pl. 47).[29] The walrus-'ivory' is often referred to as morse-ivory, after an old etymology. When carved, the tusks present a rich, lustrous and creamy white surface. However, the pulp or cavity at the root is filled with a secondary dentine which, as we have already seen, creates a severe problem for the carver: he must avoid as far as possible exposing this granular and discoloured material which can in places be close to the surface. As to the walruses themselves, they were hunted in the Middle Ages along the coasts of northern Norway, in the Barents Sea and on the shores of Greenland, although they were occasionally found to have strayed from their northerly waters; the Arctic Ocean and particularly Greenland was one of their chief habitats. The tusks were, it seems, traded through the Scandinavian ports, a point to which we will return. From Scandinavia they reached the rest of Europe, either in their raw state or already carved.[30] The whale's teeth, if indeed a few pieces of the Lewis hoard are of this material (and this is not yet certain), were available in a similar way, from similar northern waters but again the whales could appear at great distances beyond their normal habitat. The carved teeth are more compact in appearance than walrus-'ivory', with a cellular structure which runs vertically through the tooth.[31]

None of these remarks is a positive aid towards localising the Lewis hoard. What is more, none of the comparable works of art which are about to be discussed are in themselves closely datable. There is, however, one detail of dress which provides a *terminus post quem* for the chessmen, the mitres worn by the bishops. A change of fashion by which the two-horned mitre of the earlier Middle Ages began to be worn with the points forwards and backwards seems to have occurred around the middle years of the twelfth century. If this change cannot be absolutely dated from region to region, it does nevertheless present us with the fact that the Lewis chessmen are most unlikely to have been carved before the 1150s. As a broad indication of date – and to be more precise is not at the moment possible – I would propose that they belong to the second half of the twelfth century, which seems to conform well as a period with the details of their style, their foliage and ornament, their arms and armour, and their costume.[32]

5 The Lewis Chessmen and Scandinavia

The Lewis chessmen have been attributed at various times to Iceland, Norway or Scandinavia, Scotland, Ireland and England. Attributions are precisely that, no more and no less, and with the Lewis chessmen it will probably always remain to some extent a matter of opinion as to where their origins lie. By origins I do not mean to imply that we will ever know precisely where they were carved. It is unlikely, though not completely impossible, that they were carved on the Lewis itself, a point to which I shall return. However, it is indeed possible to identify the artistic milieu within which their sculptor was trained. Discoveries over the last few years have helped to strengthen enormously the case for this artistic milieu being Scandinavian, and in particular Norwegian.

Several walrus-ivory carvings present closely comparable foliage scrolls to those on the backs of the thrones (pp. 27–8). A richly carved walrus-tusk reliquary in the British Museum (pls 48–50) has no known history,[33] but the decoration of the copper-gilt mounts which were added to it in the fourteenth century has parallels that suggest an early Scandinavian provenance.[34] Its fleshy, closely-coiled foliage stems are very similar to those on certain of the Lewis thrones (pl. 10, left). A remarkable pair of walrus-ivory sword fittings (pl. 51) are also related, and the sword has been in the Royal Danish collections in Copenhagen since at least 1824.[35] Again, in 1715 a fragment of walrus-ivory (pl. 53), perhaps the head of a staff and carved with similar inhabited scrolls, was found on the island of Munkholmen, near Trondheim, far up to the north on the west coast of Norway.[36] As to the Lewis belt-buckle, which is decorated with the same elegant foliage scrolls but in low relief, no precise parallels are known, but its unusual form and construction brings to mind another walrus-ivory buckle, this time undecorated, which has been in the Royal Danish collections for two centuries (pl. 52).[37]

The style of the foliage carving of the Lewis thrones was to some extent anticipated by stone sculpture from Trondheim churches, dating from the

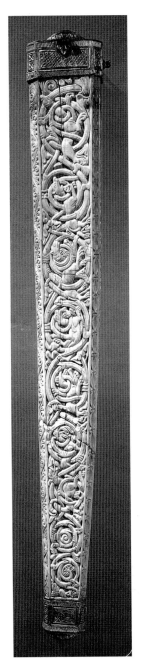

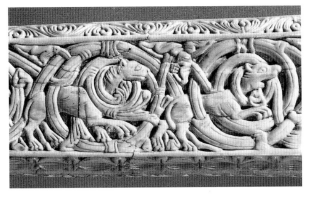

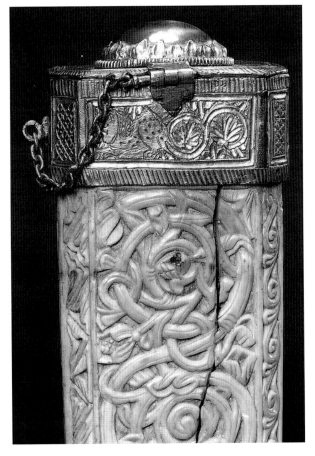

48, 49 and 50. (*Opposite*)
Walrus-ivory reliquary. Scandinavian,
1150–1200 (mounts 14th century)
(British Museum).

51. (*Right*) Walrus-ivory sword fittings.
Scandinavian, 1150–1200
(Copenhagen, NM).

52. (*Below*) Walrus-ivory belt-buckle.
Scandinavian, 1150–1200
(Copenhagen, NM).

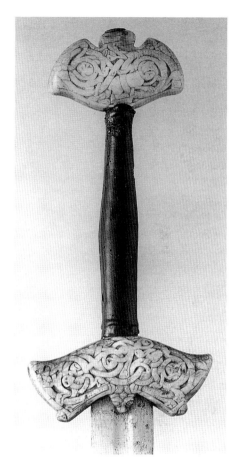

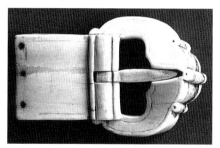

53. (*Right*)
Walrus-ivory
staff-head (?),
found on
Munkholmen.
Scandinavian,
1150–1200
(Copenhagen,
NM).

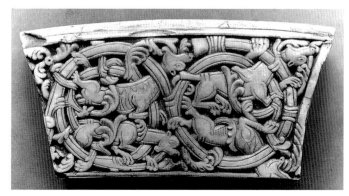

second quarter of the twelfth century.[38] Other comparisons have in the past been proposed for the foliage of the Lewis chessmen: the wood carvings of some of the Norwegian stave churches, in particular Hopperstad and Ulvik, even the foliage of the Romanesque portals of Ely Cathedral. But if these comparisons are reviewed against the group of Scandinavian walrus-ivory carvings which show such an intimate connection, they are less convincing. They imply only a general zone of influence, rather than being members of the same closely knit artistic milieu.[39] It must be admitted that it is among the peripatetic Scandinavian walrus-ivory carvings, rather than the monuments, that the closest parallels for the foliage of the Lewis chessmen are to be found. But what can be said of the figure style?

Two recent discoveries are important. A fragmentary walrus-ivory knight has been excavated in the town of Lund in southern Sweden. Pl. 55 illustrates the fragment together with a replica of one of the Lewis knights and no further commentary is required; the piece was clearly a 'Lewis knight'.[40] The second discovery is even more significant. A drawing has now been published of part of a lost walrus-ivory 'Lewis queen' (pl. 54), which was excavated in the chancel of St Olav's parish church in Trondheim in the nineteenth century.[41] It would be no exaggeration to say that the discovery of this drawing proves the existence in Trondheim of a chesspiece carved by the 'Lewis workshop'. To the Lund and Trondheim finds may be added a more general observation. The Lewis knights belong to a cultural world which was 'Nordic'; a panel of the wooden door from Valtpófsstaďur in Iceland (pl. 56) with a knight mounted in the 'Lewis manner' will underline this Norse pedigree.[42]

The archbishopric of Norway was created through the legatine visit of Cardinal Nicolas Breakspear, later Adrian IV, in 1152/3 out of the arch-diocese of Lund, which had itself come into being in 1103 as a result of splitting off from Hamburg-Bremen. The Norwegian seat of the new arch-diocese, which covered the Norwegian lands, Iceland and Greenland, was Nidaros-Trondheim (maps – pp. 6–7), where a royal palace and the great cathedral housing the bones of St Olav stood beside a town which had flourished since the end of the tenth century.[43] The archbishops of Trondheim were immensely powerful, the town market international by the second half of the twelfth century. Already Adam of Bremen, writing in

54. (*Left*)
Walrus-ivory
Queen from
Trondheim
(after McLees
and Ekroll,
1990).

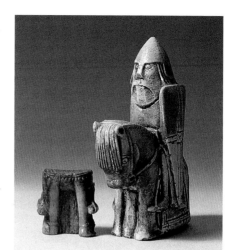

55. (*Right*)
Replica of
Lewis Knight,
compared
with frag-
ment from
Lund (Lund,
Kulturen).

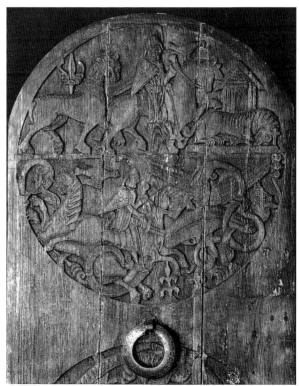

56. (*Right*) Wooden
door from Valtþófs-
staður: saga legend
of lion and knight
(Reykjavik, NMI).

the 1070s, called Trondheim 'the capital city of the Norsemen', and 'a great city'.[44] Like the other west coast ports of Norway, Bergen and Stavanger, Trondheim served the North Sea trade with Iceland and Greenland, with the British Isles and the Channel ports as well as the Baltic. In this context it is of the greatest significance that one of the main sources of walrus-ivory was Greenland.[45]

A document, admittedly much later than the twelfth century, but nevertheless of considerable relevance since it probably reflects a long-established pattern of trade, records how in 1327 the archbishop of Trondheim received a huge quantity of walrus-tusks from the Greenlanders as payment of tithe; in this case the tusks were sold by the archbishop in the Bergen market to a Flemish merchant from Bruges.[46] Such traffic, supplying the precious walrus-ivory to markets in the south, does not tell us how or where the carving of tusks took place, but it does underline the fact that the raw material itself was available in Trondheim,

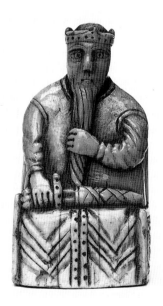
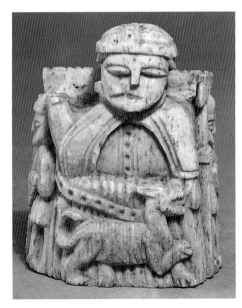

57 (*Above, left*) Walrus-ivory King. Scandinavian, about 1200 (Louvre).
58. (*Above, right*) Walrus-ivory Rook (horn-blower). Scandinavian, 14th century (British Museum).

and no doubt in other Scandinavian countries. It would be logical to go further and suggest the existence of a workshop carving walrus-ivory including gaming-pieces in a town such as Trondheim, where we also know from archaeological finds that stone, wood and bone carving flourished in the eleventh and twelfth centuries.[47]

Be that as it may, the discovery of a hoard of carved walrus-ivory gaming-pieces in the Outer Hebrides is hardly surprising, if its source was indeed Scandinavia. Until 1266 the Outer Isles were politically subject to the kingdom of Norway (maps – pp. 6–7).[48] What is more, the bishopric of the Isles, which embraced Sodor and Man as well as the Hebrides was suffragan to Nidaros-Trondheim from the moment of the foundation of the new archbishopric in the middle of the twelfth century. Every present-day inhabitant of the Lewis recognises the level of Norse tradition in the culture and language of the island. Trade between the Outer Isles and Scandinavia must have been continuous throughout the period of Scandinavian sovereignty from 1098 until 1266, even if that sovereignty was exercised at arm's length. It is not difficult to imagine the importation of the chessmen, destined for sale to the local militant aristocracy of the Isles.

To summarise, wherever the chessmen were actually carved – and Trondheim or another Scandinavian town is at the moment the strongest candidate – there is considerable evidence that the 'Lewis workshop' belonged to the milieu of Scandinavian Romanesque art of the twelfth century. What is more, other surviving pieces (pl. 57), none with a secure history and all of later date, seem to suggest that chesspieces in a 'sub-Lewis manner' went on being carved in Scandinavia for the European markets.[49] Even in the late Middle Ages, certain walrus-ivory chessmen can claim to be Scandinavian, although again this cannot be absolutely proved (pl. 58).[50]

6 The Lewis Chessmen and Romanesque Europe

The Lewis chessmen occupy a unique place within the art of eleventh- and twelfth-century Europe. They are the largest single surviving group of secular Romanesque objects made for leisure and enjoyment, almost certainly for an aristocratic laity. The playing of chess is their sole *raison d'être*. This may seem a truism, but so often with Romanesque artefacts it is difficult to gauge their intended function. However, this having been said, a fundamental question about them remains to be answered: how would they have been judged by contemporaries? To take a parallel example, one has only to think of the series of figured corbel-tables which decorated the exteriors of twelfth-century churches in certain parts of Europe. Although their function as part of the embellishment of a church is unambiguous, their message is not: some are fantastical, humorous or grotesque, no doubt intended to entertain, others were perhaps there to instruct.[51] Pl. 59 illustrates a mailed soldier cutting the throat of an adversary; the 'message' he was meant to convey is not exactly obvious.[52] With the Lewis chessmen it is most unlikely that they were intended as humorous (many visitors to the Medieval Gallery of the British Museum find them 'endearing' or 'funny'). Rather the kings were probably intended simply to convey wisdom or royalty, while the queens adopt the traditional pose of composure and patience. As to the knights and warders, they are 'warlike'. Madden was the first to interpret the iconography of the warders who bite their shields (pl. 31) as a reflection of a literary tradition enshrined in some of the Norse sagas that these are *Berserkars*, that is the armed warriors who worked themselves into such a frenzy before battle that they bit their shields.[53]

There is finally a wider context for the Lewis chessmen. No earlier surviving 'bishops' in full ecclesiastical dress are known. Here within the hierarchies of 'Feudal Society', the Church takes its place on the chess-board, with a status lower than that of the kings and queens.[54] What is more, it is a fact frequently attested in documents that the medieval

Church took a dim view of members of the clergy who played chess.[55] Could the arrival of the vested bishop on the chessboard be seen as a satirical comment on contemporary society? In any case, the Lewis chessmen reflect a particular stage in the evolution of the game itself, away from its purely military roots and towards embodying the various hierarchies of society, royal, ecclesiastical and knightly. This evolution still had a long way to go before chessmen would come to embrace the courtly and chivalric fashions of Gothic Europe (pl. 43).[56]

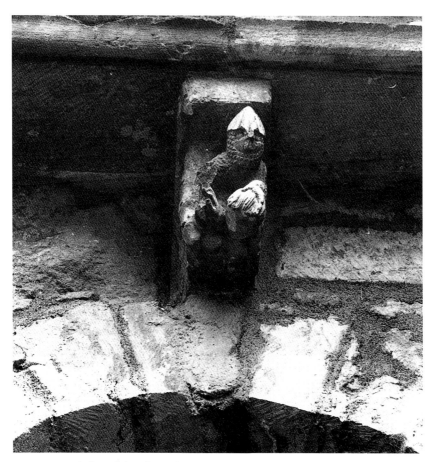

59. Stone corbel, with knight and victim. Anzy-le-Duc, priory church, about 1130.

Appendix A
Accounts of the discovery of the Lewis hoard

(a) Extract from the minutes of the Society of Antiquaries of Scotland: Monday Evening 11th April 1831. Sir Henry Jardine, Vice President in the Chair.

There were likewise exhibited by permission of Mr. Roderick Pirie of Stornoway, a number of figures carved in ivory, apparently chessmen and of Scandinavian workmanship in the middle ages, which were lately found buried fifteen feet under a bank of sand in the Island of Lewis. Some extracts of a letter regarding the discovery of these interesting curiosities were read to the Society.

Laing, 1833 (1857), p. 369, comments on the meeting:

No copy of this letter is preserved among the Society's papers. But it is evident, that to serve some purpose, contradictory statements were circulated by the persons who discovered or who afterwards obtained possession of these Chess-men, regarding the place where the discovery was actually made.

(b) Madden, 1832, p. 212:

A Scottish newspaper reported in June 1831 that the find was made by 'a peasant of the place, whilst digging a sandbank'.

(c) Laing, 1833 (1857), p. 368:
In a note, Mr. Sharpe [Charles Kirkpatrick Sharpe] says –

These chess-men discovered in the Isle of Lewis had never been under water; they were found in a vaulted room (as it was described to me), about six feet long; they were slightly covered with sand, and there was a quantity of ashes on the floor.

I could not learn whether there was anything like a chimney. The room is near a spot where tradition affirms a nunnery once stood. The name of the place in Gaelic signifies – 'The house of the black women.'

(d) Macleod, 1833 (1845), p. 153:

In the year 1831, a considerable number of small ivory sculptures resembling chessmen, and which appeared to be of great antiquity, were found in the sands at the head of the bay of Uig, and have been since transmitted to the Antiquarian Society at Edinburgh.

(e) Wilson, 1851, p. 567:

In the spring of 1831, the inroads effected by the sea undermined and carried away a considerable portion of a sandbank in the parish of Uig, Isle of Lewis, and uncovered a small subterranean stone building like an oven, at some depth below the surface. The exposure of this singular structure having excited the curiosity, or more probably the cupidity, of a peasant who chanced to be working in the neighbour-hood, he proceeded to break into it, when he was astonished to see what he concluded to be an assemblage of elves or gnomes upon whose mysteries he had unconsciously intruded. The superstitious Highlander flung down his spade, and fled home in dismay; but incited by the bolder curiosity of his wife he was at length induced to return to the spot, and bring away with him the singular little ivory figures, which had not unnaturally appeared to him the pigmy sprites of Celtic folk-lore.

Wilson, 1851, p. 575:

This supposition, however, was formed under imperfect information of the circumstances attending the discovery, as they were found in a stone building, which, from the general description furnished of it, there appears reason to assume, must have been a Scottish Weem, and in the vicinity of a considerable ruin. There is greater probability in the earlier conjecture, that the carving of these ancient chessmen may have helped to relieve the monotony of cloistral seclusion.

(f) Thomas, 1863, pp. 412–13:

The Uig Chessmen.

'George Mor Mackenzie was tacksman of the farm of Balnakill and other lands, in the parish of Uig; and at one time he had yeld cattle at a remote shieling in the southern end of the parish, called Aird Bheag, near the entry to Loch Resort. Mackenzie employed a young man to herd the cattle there; and on a stormy night a ship was driven ashore at Aird Bheag.

On the following morning, Mackenzie's herd saw from a hiding-place a sailor swimming ashore with a small bag upon his back. The herd pursued the sailor, overtook and slew him without ceremony, hoping to find riches and money on him. Burying the sailor in a peat-moss, he went to Balnakill to inform his master of the fate of the ship, advising him to kill the crew, and possess himself of the wealth the ship was supposed to contain. But Mackenzie reprimanded his herd for this barbarous advice, and directed him by no means to do them harm, but to conduct the survivors to his house. So the crew all safely arrived at Balnakill, excepting the sailor whom the herd had murdered. Mackenzie showed all manner of kindness to the strangers, who stayed about a month with him, and in that time they

saved as much from the ship as more than satisfied Mackenzie for their keep.

When the shipwrecked seamen left the country, the wicked herd, always afraid of detection, though living in a remote corner of the parish, went to where he had concealed the bag for the sake of which he had murdered the sailor, to examine the contents. These turned out to be carved relics of various descriptions, and fearing the figures might be turned to proof against him, he travelled not less than ten miles in a dark night, and buried the carved images in a sand-bank in the Mains of Uig. This herd never prospered thereafter, but went on from bad to worse, until, for his abuse of women, he was sentenced to be hanged on the Gallows Hill, at Stornoway. When he was brought forth for execution, he told of many wicked things which he had done, and among others, how he had murdered the sailor, and where he had buried the images.

Thereafter, in A.D. 1831, Malcolm Macleod, tenant of Penny Donald, in Uig, found upwards of eighty of these carved relics; and those images were sold in Edinburgh by the late Captain Ryrie, for L. 30, for the above Malcolm Macleod.'

Such is the tradition, noted by Mr. Morrison of Stornoway, who was for many years a resident in the parish of Uig, and was intimately acquainted with the folk-lore of that district.

(g) P. S. A. Scot., 1888–9, p. 9, Museum Accessions:

Eleven Chessmen of walrus ivory – found in the island of Lewis in 1831. There is no circumstantial account of the discovery, but from a comparison of the various statements it appears that they were found in a chamber of dry-built stone which had been disclosed by the partial washing away of a bank of sand about 15 feet deep,

at the head of the Bay of Uig, in the island of Lewis. They were slightly covered with sand, and it was observed that there was a quantity of ashes on the floor of the chamber. The site of the nameless structure in which they were found is described as not far distant from another site said to be well known as *Tigh nan Caillachain dhu nan Uig* – the house of the black women of Uig.

(h) R. C. A. H. M. C. Scot., 1928, pp. 23–4 (report of 8 July 1814):

In a wind-swept gully in the sand ... about 400 yards south of the high-water mark on the southern shore of Uig Bay ... The ... chessmen ... were found in this gully ... The articles were exposed by a cow rubbing itself against a sandhill.

(i) ed. Macdonald, 1967, pp. 120–3:

THE LEWIS CHESSMEN – recovered in 1831 at Ardroil by Rev. A. J. MacKenzie.

This story used to be told in a ceilidh house near the old sanctuary of Balnacille when he [Rev. A. J. MacKenzie] was a boy but there are other variations of the tale:

The beginning of the seventeenth century saw the end of the war between the Macleods and the MacKenzies for the possession of Lewis. Neil Macleod had been beguiled from his island fortress of Beirisay, taken to Edinburgh, and executed at the market cross in 1613, and the direct line of Siol Torquil came to an end soon afterwards.

When the MacKenzies took over in 1610, clansmen from Kintail followed the Chief who gave them farmlands, and among them was Calum Mór, noted for his skill as an archer and swordsman. To him

the Chief gave Baile-na-Cille, and also some rough pasture in the Ard Mhór beyond the mountains which shut in Uig, and here in summer, his cattle used to graze in a long glen strewn with great boulders through the hills all along to Loch Hamnavay. The cattle were in charge of the 'Gille Ruadh' or red gillie, and on one of the days he was herding the cattle he climbed to the top of Ardmore and lo! he saw a ship riding at anchor in the loch below. There was no sign of life anywhere. He hid himself in an alcove in a cairn, and watched to see what would happen. At moonrise he noticed a small dinghy being rowed to the shore, from which a sailor boy jumped to land holding a weighty bundle. The place where the boat came ashore is still called Gleann-na-Curach. The 'Red Gillie' watched the boy and from his movements, judged he wanted to get away from that ship. The 'Red Gillie' left his hiding place and by a round-about route met the boy at the bend of the glen where the river sweeps past the great boulders of Diuire (Guire).

The 'Red Gillie' spoke to the boy, who told him he was tired of living with a rough crew and had made up his mind to escape though he did not know what kind of country he was in, but he thought any land would be better than living with the kind of drunken sots that comprised the crew. As he had no money, he had taken away the playthings with which the sailors amused themselves, hoping to be able to sell them later on. The 'Red Gillie' was most kind and took the boy into the shelter of the cave formed of boulders where he was told the boy's story about the bundle, and 'once again as ten million million times it had happened before and as ten million times it will happen again, the wicked prospered and the righteous suffered: but the wicked shall not prosper for ever, says the Great Book.' The herd servant, overcome by greed and a desire to

own the bundle, attacked the boy, killed him, and buried him in the cavern.

The 'Red Gillie' set out for home and arrived just as the first pale gleam of dawn was tingeing the sky. He hid the bundle of treasure, and some time later when his master appeared, he told him about the ship at Ard Mhór and suggested that he – the master – should take some of his men and plunder her before she set sail again for the open sea. The master, Calum Mór, was horrified, and sternly commanded him never again to show his face within sight of the lands of Balnacille. Thus he was prevented from unearthing his treasure, which he had buried in the sands of Uig, for he never saw these sands again. He tried his fortune around Stornoway, where he was caught red-handed in a dastardly deed for which he was hanged on Gallows Hill. The Lord Kintail raised this new erection – the gallows – on the hill across the bay opposite the ancient stronghold of the Siol Torquil. Among a long list of crimes to which he confessed was the story of the sailor boy and his treasure bundle. No one would believe his story and so the sand dunes of Uig kept the secret of the buried treasure.

Then one day in 1831 Malcolm Macleod of Penny Donald, known as Calum nan Sprot, was herding his cattle amongst the sand dunes when he saw one of the beasts rubbing itself against a 'baca gainmhich' and acting in a queer manner, so he went along to investigate and saw her pull out some whitish objects with her horn. He lifted some of them up and examined them, and took them to be idols or graven images of some kind which he did not understand. A gentleman from Stornoway heard of the discovery and came over and dug out all the pieces, for Calum nan Sprot would meddle no more with them. There were eighty pieces in all, and when they were put into a creel they made a substantial burden for a man.

They were taken to Stornoway, and at length found their way to the museums of London and Edinburgh where they can be seen to this day. Incidentally, Calum nan Sprot, who showed some scruples about having the 'idols' in his possession, had no scruples about taking a reward for his discovery. He received £30!! Thus after the lapse of more than two hundred years, the hidden treasure of an unknown sailor boy who had been treacherously done to death by the red-haired handyman in the fastness of the Ard Mhór, was again brought to light, and the truth of an old 'sgeulachd' substantiated.

Appendix B
Technical observations

1. All the pieces appear to be carved from walrus tusks, except 119 and 121 (2 warders), 126 and 133 (2 pawns) and (Edinburgh) NS 28–9 (2 warders): some or all of these may possibly be from whale's teeth (microscopic examination by Caroline Cartwright, British Museum Department of Scientific Research; David Caldwell and Andrew Kitchener, National Museums of Scotland). The hoard requires further study.

2. Some dimensions (in cm) of the pieces are:

(Kings) H. (max) 10.2 (min) 7.3
(Queens) H. (max) 9.6 (min) 7
(Bishops) H. (max) 10.2 (min) 7.3
(Knights) H. (max) 10.3 (min) 7.2
(Warders) H. (max) 9.2 (min) 7
(Pawns) H. (max) 5.8 (min) 3.5
(Disks) Diam. 5.5/6
(Belt-buckle) W. 6.1

3. The condition of the pieces is extremely variable, from near-perfect to degenerating, the latter group having presumably been buried in a damper area than the former. The surfaces are frequently channelled by tiny insects such as exist in sand. The whiteness and clean texture of the best-preserved British Museum pieces stand in marked contrast to their Edinburgh counterparts which have a greyish surface. It is not known whether the British Museum pieces were given a surface cleaning either by Forrest or in the Museum, but the recent Department of Scientific Research examination (see p. 55 for report) suggests that such a cleaning was at the very most very discreet; some allowance must also be made for fading, given the natural light levels to which the pieces have been subjected for over 160 years in the public exhibition galleries. As to the Edinburgh pieces, it is not possible to say whether their greyish texture is closer to their original condition in 1831 or, on the contrary, the result of a subsequent surface treatment by Sharpe, Lord Londesborough or the National Museums.

4. Little evidence has been found for the tools used to carve the chessmen, except where on certain pieces (see pl. 37 – Iv. Cat. 114 (knight)) areas were left unfinished, revealing tooling with a tiny punch. Eye-pupils were formed with a small circular punch. On the draughtsmen, a central compass point survives from which the concentric circles of the borders were engraved with a fine point. The left side of the throne of the queen NS22 (Goldschmidt 232) (pls 15, 16) is cut from a separate piece of walrus-tusk and pinned into position. This is clearly a mend contemporary with the original carving, perhaps made necessary by an error or breakage in the course of work.

5. Madden, 1832, was adamant that he saw traces of red staining on certain pieces and this statement must be accepted. The pieces identified by Madden as stained red were: Iv. Cat. 80 (king), 86 (queen), 92, 93 and perhaps 95 (bishops), 100 (bishop), 102 (knight), 125 (warder), plus several unidentified pawns. Subsequent fading (see (3) above) may account for the fact that the new Department of Scientific Research examination (see p. 55) has not been able to identify positively whether the apparent traces of staining are natural or artificial. The same report has isolated a few traces of green on the original surfaces, which may or may not be a pigment.

The British Museum Department of Scientific Research

Report on the examination of the Lewis Chessmen for possible traces of pigment

The condition of the pieces is very variable. Surfaces range from continuous and glossy, perhaps essentially as originally polished, to rough and cracked, with the underlying structure of the ivory brought into relief by weathering.

Surfaces have commonly lost some material due to chipping. In addition, worm-like channels are present on many surfaces. These may have originated due to etching by acids secreted by plant rootlets or alternatively by grazing organisms. The presence or absence of coloured material in these corrosion features gives a good indication as to whether the colour was original.

The identification of traces of original colour on objects which have been handled and displayed over 150 years or so is far from straightforward. To avoid errors, we adopted a strategy whereby acceptance of a colour trace as original pigment required the agreement of all our scientists involved, based upon independent examinations using a binocular microscope at magnification × 6 to × 50.

As it turned out, very little, if any, unambiguous evidence for original pigment was observed on the chessmen. The most intriguing traces were minute patches of green, ranging from 0.1-1.0 mm in size, which occur on four pieces (85, 86, 92, 107). These flecks have a rather waxy appearance, and always occur on smooth original surfaces rather than on broken or weathered ones. On one piece (92, bishop), the green is associated with a white material which X-ray fluorescence analysis suggests is lead-rich and may be a lead white pigment. While these green areas are the most likely traces of original pigment observed, there are reservations. In particular, why are these traces so sparse and why is the green preserved on prominent polished surfaces and not in the recesses of the carving, where conditions for preservation would be more favourable? These reservations suggest that it would be prudent to exercise caution in the interpretation of the green traces.

In addition to the fine, loosely bound red or brown iron oxide particles which are commonly seen on museum objects which have been in storage for long periods, a more extensive area of red was seen on one object (90, bishop). Here traces of a bright red material occur within and adjacent to a cut at the true left side just above the base of the crozier; similar material is also present on what appears to be a break or roughened surface on this piece leading us to conclude that it is unlikely to be original.

A number of the pieces have a reddish hue or stain which Madden (1832) suggested was some sort of dye. Examination under the microscope revealed no associated particulate matter; if original colour, then this was probably a dye which had soaked into the ivory. However, the reddish colouration is now so faint that the notion that it is a deliberate colouration rather than some weathering effect does not impress itself upon the observer. It is possible, however, that a more intense red was observed by Madden, which has faded during the intervening period when the objects have been on display.

C. P. Stapleton

M. S. Humphrey

A. P. Middleton

I. C. Freestone

Notes

1 Bodl. MS Eng. hist. C. 148, p. 61.

2 ed. W. E. K. Anderson, *The Journal of Sir Walter Scott*, Oxford, 1972, p. 667. Madden in his journal (*op. cit.*, note 1, p. 57) gives an amusing account of Scott's 'uncouth' physical appearance at this time.

3 BM, Central Archives, Original Papers, Vol. IX (letter of Forrest to Hawkins 22 October 1831); Minutes of Trustees' Standing Committee, pp. 3403–4 (12 November 1831), 3434 (14 January 1832).

4 BM Central Archives, Class CE5 (Officers' Reports), no. 14 (no. 2959) – dated November 1831.

5 For Sir Frederic Madden (1801–73), see *DNB*. His skill as a chess-player is clear from a review published in *The Gentleman's Magazine*, CII, Part I, May 1832, p. 432.

6 Madden, 1832. Madden's paper was read to the Society of Antiquaries at two successive meetings on 16 and 23 February 1832. The original drawings from which the engraved plates were made for the *Archaeologia* article are in the Society of Antiquaries, Portfolio 'Utensils and Furniture', fols 45–7. See pl. 2.

7 P. S. A. Scot., 1888–9, p. 10. For the minutes of the Scottish Antiquaries Meeting of 11 April 1831, see Appendix A.

8 Kirkpatrick Sharpe is quoted already in 1833 with a description of the chamber in which the chessmen were found: 'in a vaulted room (as it was described to me), about six feet long; they were slightly covered with sand, and there was a quantity of ashes on the floor.' (see Appendix A (c)). See also Burgess and Church, 1995.

9 Carol Cunningham and Anna Mackinnon of the Uig Historical Society showed me the approximate site in June 1995. See also R.C.A.H.M.C. Scot., 1928, pp. 23–4, map.

10 In his paper to the Society of Antiquaries of Scotland on 11 March 1833, David Laing wrote: 'I understand, they were actually found inside of a building where they could not possibly have been subjected to the action of sea-water.' (Laing 1833 (1857), pp. 367–8).

11 Reference to the episode in Laing 1833 (1857), p. 367; R. B. K. Stevenson, in ed. A. S. Bell, *The Scottish Antiquarian Tradition*, Edinburgh, 1981, p. 72.

12 For Charles Kirkpatrick Sharpe of Hoddam, Dumfriesshire (1781?–1851), see *DNB*; *Gentleman's Magazine*, CXXI, Part I, May 1851, pp. 557–9. For his purchase of the eleven chesspieces, see Laing, 1833 (1857), p. 368; P. S. A. Scot., 1888–9, pp. 10–11. The Sharpe sale by Messrs. C.B. Tait and T. Nisbet of 11 Hanover Street, Edinburgh, was 12–18 June 1851, Lot 531 (14 June), purchaser Forrest for £105, for Lord Londesborough.

13 *Miscellanea Graphica*, 1857 (description of the pieces in the Londesborough collection); Londesborough sale, Christie's 4–11 July 1888, Lot 747. For Albert Denison, first Baron Londesborough (1805–60), see *DNB*.

14 The evidence for this is contained in a letter of Franks to Dr Joseph Anderson, the Assistant Secretary of the Society of Antiquaries of Scotland, dated 30 June 1888 (BM, MLA Letter-Books, fol. 252–3). See also Madden's journal entry for 10 June 1851 (*cit.*, note 1), which makes it clear that Franks went to Edinburgh for the Sharpe sale and that Forrest had made positive assurances in 1831 that the Museum was acquiring 'the whole that were found'.

15 Six pieces have been tentatively identified as carved from whale's teeth (see Appendix B).

16 Taylor, 1978, p. 15.

17 For walrus 'ivory', see *Rowland Ward's Records of Big Game*, 8th edition, London, 1922, pp. 508–9 (the longest recorded tusk is 37 1/4 in, the biggest circumference is 10 3/4 in). See also T. K. Penniman, *Pictures of*

Ivory and other Animal Teeth Bone and Antler, Pitt Rivers Museum, University of Oxford, Occasional Papers on Technology, 5, n.d. (1952), pp. 25–6, pls. VIII–IX; MacGregor, 1985, p. 18, figs. 17b, 19, 74; Roesdahl, 1995.

18 Pastoureau, 1990 (a) and (b) makes a plausible case for certain elaborate chess-pieces having been carved as objects to be admired and treasured, not played with.

19 Madden, 1832; Murray, 1913; Gamer, 1954 contain good accounts of the early history of the game, but resumés can be found in all the general books on chessmen listed in the Bibliography.

20 Gamer, 1954.

21 For Islamic gaming-pieces, see now Contadini, 1995.

22 Paris, Louvre, OA 3297: H. 6.4 cm. With traces of gilding. See Goldschmidt, IV, 1926, no. 180; Beckwith, 1972, no. 165, illus. 259–60; Pastoureau 1990 (a), pp. 15 (no. 13), 37 (fig. 21). The piece has no known history before 1892. It shows on one side and the two ends three scenes from the Adam and Eve story, and on the other face two knights in combat.

23 Pl. 41 illustrates a Romanesque king, apparently of bone, which was found on the site of Dorf Langenbogen, near Mansfeld in Saxony in the nineteenth century; H. 10 cm; w. (max) 5 cm; D. 4.5 cm. It may have been in a Darmstadt collection, prior to belonging to Robert von Hirsch (sale Sotheby's 22 June 1978, Lot 272). Its present where-abouts is unknown. See also Goldschmidt, III, 1923, no. 159.

24 Tronzo, 1977.

25 Pl. 44 illustrates 4 of a set of 29 counters, the largest Romanesque set in existence: Diam. 6 cm (British Museum, MLA Iv. Cat. 173–201). The set belonged to Horace Walpole at Strawberry Hill. See Goldschmidt, III, 1923, nos 272–300; *Horace Walpole and Strawberry Hill*, catalogue of exhibition, Orleans House Gallery, Twickenham,

20 September – 7 December 1980, no. 153. The ivory comb found in St Cuthbert's tomb at Durham was coloured red, see C. R. Dodwell, *Anglo-Saxon Art. A new perspective*, Manchester, 1982, pp. 37, 253 (note 139).

26 Pl. 43 illustrates an elephant-ivory mirror-back in the Victoria and Albert Museum (Inv. 803–1891): Diam. 10.8 cm. See Raymond Koechlin, *Les Ivoires Gothiques Français*, Paris, 1924, no. 1046, pl. CLXXX.

27 For the enamel plaque of Geoffrey Plantagenet, see Jules Labarte, L'émail de Geoffroy ou de Henri Plantagenêt au Mans, in *Bulletin Monumental*, 1865, pp. 7–89; Marie-Madeleine Gauthier, *Emaux du moyen âge occidental*, Fribourg, 1972, pp. 81–3 (illus.), 327 (no. 40); id., Art, Savoir-Faire Médiéval et Laboratoire Moderne, à propos de l'effigie funéraire de Geoffroy Plantagenêt, in *Comptes rendus de l'Académie des Inscriptions et Belles-Lettres*, 1979, pp. 105–31. For the heraldry, *British Heraldry from its origins to c. 1800*, catalogue ed. Richard Marks, Ann Payne, British Museum, 1978, pp. 10–11, 16 (cat. no. 1). I thank John Goodall for his advice on the arms, armour and heraldry.

28 Dalton, 1928; Riddler, 1995, p. 102.

29 For references to walrus-ivory and its structure, see note 17 above. Pl. 47 illustrates Dürer's famous watercolour in the British Museum (P&D 5261–167 (Sloane Bequest, 1753)): 21.1 × 31.2 cm. Inscribed: '1521/That stupid animal of which I have portrayed the head was caught in the Netherlands sea and was twelve brabant ells long with four feet.' See John Rowlands, *Drawings by German artists ... in the Department of Prints and Drawings in the British Museum*, 2 vols, British Museum Press, 1993, I, no. 219; II, pl. 149. See also the article by Seaver, cited note 30.

30 Apart from the Bibliography cited note 17, see V. Kiparsky, *L'Histoire du Morse*, Suomalaisen Tiedeakatemian Toimituksia (Annales Academiae Scientiarum Fennicae),

Series B, vol. 73, no. 3, Helsinki, 1952, pp. 1–54 (for the etymology of *morse*); Bent Muus, *et. al.*, *Grønlands Fauna*, Copenhagen, 1981, p. 405 (for map of the distribution of the Atlantic walrus); Kirsten A. Seaver, 'A very Common and Usuall Trade': The Relationship between Cartographic Perceptions and 'Fishing' in the Davis Strait circa 1500–50, in *British Library Journal*, 22, Part I (Spring 1996).

31 See Penniman; MacGregor (*op. cit.*, note 17).

32 Taylor, 1978, pp. 14–15, quotes the evidence of seals for this *terminus post quem*. Heslop, 1980, reviews the question and suggests that the 1150s–1160s saw the first 'gabled mitres' appear on German and English seals. His general conclusion is that the chessmen may rather date towards the end than the middle of the twelfth century, on the basis of the costume.

33 BM, MLA 1959,12-2,1 (purchased Sotheby's 8 December 1959, Lot 108, for £9,500 with the aid of contributions from the Pilgrim Trust and the National Art Collections Fund). First recorded in 1905 in the collection of Emile Molinier, later Heugel, Charles Lowengard, Salman collections. See Lasko, 1960–1; Taylor, 1978, figs 6(c), 7(b), 8(b); Stratford, 1992–3, no. 611.

34 For the Gothic mounts of the tusk with their grotesques, Erla Hohler has proposed to me a comparison with a small engraved metal fragment found in Oslo old town (Oslo, Universitets oldsaksamling, c.32437). Fritze Lindahl has cited in correspondence the mounts on the celebrated Horne book-cover in the Nationalmuseet, Copenhagen (Liebgott, 1985, p. 36 (fig. 29)).

35 Copenhagen, Nationalmuseet, Inv. 9105: w. (guard) 7.2 cm; (pommel) 5.2 cm. See Goldschmidt, III, 1923, no. 142; Taylor, 1978, fig. 7 (c). The sword was in the royal Danish collection by 1824 (Inv. no. BDc 17).

36 Copenhagen, Nationalmuseet, Inv. 9101: w. (max) 12.5 cm. See

Goldschmidt, III, 1923, no. 143; Blindheim, 1972, pp. 74–5 (Cat. no. 47); McLees and Ekroll, 1990 p. 153; Lindahl, 1992–3.

37 Copenhagen, Nationalmuseet, Inv. 9113: w. 9.5 cm. See Liebgott, 1985, p. 27 (fig. 17); Lindahl, 1992–3, p. 388 (Cat. no. 606). The belt-buckle is first mentioned in 1795 (Inv. no. BCb 34).

38 The comparison with Trondheim sculptures was first proposed by Blindheim, 1972, p. 20 (no. 1). I am grateful to Erla Hohler who in a letter refined on Blindheim's remarks by singling out the capital illustrated by Blindheim, 1965, fig. 17, which comes from an unknown source in Trondheim and is symptomatic of a phase of carving prior to the construction of the Romanesque Transept of the Cathedral, i.e. in the first half of the twelfth century. For Romanesque Trondheim Cathedral, Fischer, 1965, Chapter IV.

39 Erla Hohler has pointed out the exceptional position occupied by the Hopperstad and Ulvik carvings among the general run of Norwegian stave churches, postulating an ultimately English origin for some of the foliage motifs. It seems to me that as with Ely the similarities with the Lewis chessmen are of a general kind. Here I part company from Taylor, 1978 – see his figs 9–11 and pl. inside the back cover.

40 Lund, Kulturen, KM 72.250:45 (found in the excavations at Kv. Billegården 49, Lund): H. 2.8 cm. The piece was drawn to my attention by Else Roesdahl and published in Wahlöö, 1992–3.

41 McLees and Ekroll, 1990.

42 For the wooden door of Valtpófsstaður, see Peter Paulsen, *Drachenkämpfer, Löwenritter und die Heinrichsage. Eine Studie über die Kirchentür von Valthjofsstad auf Island*, Köln/Graz, 1966.

43 For the medieval town of Trondheim, see Clifford D. Long, Excavations in the Medieval City of Trondheim, Norway, in *Medieval Archaeology*, XIX, 1975, pp. 1–32; K. Helle,

A. Nedkvitne, *Norge - Sentrumsdannelser og byutvikling i norsk middelalder, Urbaniseringsprosessen i Norden*, I, pp. 189–286 (Trondheim); Øyvind Lunde, *Trondheims fortid i bygrunnen*, Trondheim, 1977.

44 Adam of Bremen, Gesta Hammaburgensis ecclesiae Pontificum, ed. Werner Trillmich, in *Quellen des 9. und 11. Jahrhunderts zur Geschichte der Hamburgischen Kirche und des Reiches*, Berlin, 1961, pp. 300 (Bk II, 61, 20–21: the body of St Olaf king and martyr was buried 'in civitate magna regni sui Trondemnis'), 484 (Bk iv, 33 (32): 'Metropolis civitas Nortmannorum est Trondemnis, quae nunc decorata ecclesiis magna populorum frequentia celebratur').

45 See Muus (*op. cit.*, note 30).

46 P. A. Munch, *Porvelige Nuntiers Regnskabsog Dagböger ... 1282–1334*, Christiania, 1864, p. 25.

47 Long, *op. cit.*, note 43; Signe Horn Fuglesang, 'Woodcarvers – Professionals and Amateurs in Eleventh-Century Trondheim', in ed. David M. Wilson, Marjorie L. Caygill, *Economic Aspects of the Viking Age*, BM Occasional Paper, no. 30, 1981, pp. 21–31. For an early medieval walrus-ivory production in Novgorod, related to the White Sea walrus hunts, see L. I. Smirnova, 'Walrus Ivory Combs from Novgorod', in ed. I. D. Riddler, N. I. A. Trzaska-Nartowski, A. MacGregor, *Combs and Comb-Making*, London (forthcoming).

48 Duncan and Brown, 1956–7.

49 Pl. 57 illustrates a walrus-ivory king in the Louvre (OA 5541), perhaps of the late twelfth century but with no early history: H. 8.4 cm. See Pastoureau, 1990 (a), fig. 21, no. 13; Pastoureau, 1990 (b), p. 53 (fig 38). Another piece closely related to the Lewis hoard is a knight in the Bargello, Florence – see *Arti del Medio Evo e del Rinascimento. Omaggio ai Carrand 1889–1989*, catalogue of exhibition Museo Nazionale del Bargello, 20 marzo – 25 guigno 1989, pp. 239–40 (Cat. no. 22).

50 Pl. 58 illustrates a walrus-ivory rook (?) in the British Museum (Iv. Cat. 391): H. 7.4 cm. The seated figure was originally blowing a horn. It was apparently acquired in the 1850s, indirectly from a Copenhagen collection. It may date from the later fourteenth century.

51 An extreme position as to the 'meaning' of such corbels is adopted by Nurith Kenaan-Kedar, The Margins of Society in Marginal Romanesque Sculpture, in *Gesta* XXXI/I, 1992, pp. 14–24 (with previous Bibliography).

52 Pl. 59 illustrates a corbel on the exterior of the south aisle of the priory church of St Martin at Anzy-le-Duc in southern Burgundy. For an up-to-date Bibliography on Anzy-le-Duc, see *Congrès Archéologique de France*, 1991 (Bourbonnais), p. 337 (note 31).

53 Madden, 1832, pp. 271–2.

54 For twelfth-century attitudes to rank and to the hierarchies of society, see for instance Georges Duby, *Les trois ordres ou l'imaginaire du féodalisme*, Editions Gallimard, 1978; Susan Reynolds, *Fiefs and Vassals. The Medieval Evidence Reinterpreted*, Oxford, 1994, *passim*.

55 The celebrated Camaldoli monk, Saint Peter Damian, in a letter to Pope Alexander II of 1058 attacked bishop Gerard of Florence, complaining of clergy who play games of chance, including a form of chess with dice (*Die Briefe des Petrus Damiani*, ed. Kurt Reindel, vol. 2, *Monumenta Germaniae Historica*, München, 1988, pp. 187–8 (Letter 57)). As to the British Isles and interdicts on chess for the clergy, see Otto Lehmann-Brockhaus, *Lateinische Schriftquellen zur Kunst in England, Wales und Schottland vom Jahre 901 bis zum Jahre 1307*, 5 vols, Munich, 1955–60, nos 201, 1073, 2117, 3948, 6543.

56 Pastoureau, 1990 (a), 1990 (b).

Bibliography

Abbreviated Titles

P.S.A. Scot. Proceedings of the Society of Antiquaries of Scotland.

R.C.A.H.M.C. Scot. The Royal Commission on Ancient and Historical Monuments and Constructions of Scotland.

Iv. Cat. Dalton, 1909

DNB Dictionary of National Biography

N.M.A.S. National Museum of Antiquities of Scotland.

BECKWITH, 1972. John Beckwith, *Ivory Carvings in Early Medieval England*, London, 1972, Cat. 166, illus. 26 1–5.

BLINDHEIM, 1965. Martin Blindheim, *Norwegian Romanesque Decorative Sculpture 1090–1210*, London, 1965.

BLINDHEIM, 1972. Martin Blindheim, in *Norge 972–1972. Middelalderkunst fra Norge i andre land. Norwegian Art Abroad*, catalogue of exhibition, Universitets Oldsaksamling, Oslo, 1972, pp. 19–21 (Cat. no. 1), *passim*.

BURGESS and CHURCH, 1995. C. Burgess, M. Church, Uig Landscape Survey: Uig Sands to Aird Uig, Isle of Lewis, Uig Parish, in *University of Edinburgh, Department of Archaeology, 41st Annual Report*, 1995, pp. 35–6.

CALDWELL, 1982. David H. Caldwell, in *Angels, Nobles and Unicorns. Art and patronage in medieval Scotland*, catalogue of exhibition, National Museum of Antiquities of Scotland, Edinburgh, 1982, pp. 27–8 (cat. B42).

Cat. Manchester, 1959. *Romanesque Art c.1050–1200 from collections in Great Britain and Eire*, City of Manchester Art Gallery, 22 September – 1 November 1959, p. 39 (no. 84).

Cat. NMAS, 1892. *Catalogue of the National Museum of Antiquities of Scotland*, new and enlarged edn, Edinburgh, 1892, pp. 374–5 (NS 19–29), illus.

CONTADINI, 1995. Anna Contadini, Islamic Ivory Chess Pieces, Draughtsmen and Dice, in ed. James Allan, *Islamic Art in the Ashmolean Museum*, I, Oxford, 1995, pp. 111–54.

DALTON, 1909 [IV. CAT.]. O. M. Dalton, *Catalogue of the Ivory Carvings of the Christian Era in the British Museum*, London, 1909.

DALTON, 1928. O. M. Dalton, Early Chessmen of Whale's Bone excavated in Dorset, in *Archaeologia*, LXXVII, 1928, pp. 77–86 (paper read 16 December, 1926).

DUNCAN and BROWN, 1956–1957. A. A. M. Duncan, A. L. Brown, Argyll and the Isles in the earlier Middle Ages, in *P.S.A.Scot.*, XC, 1956–1957 (1959), pp. 192–220.

FISCHER, 1965. Gerhard Fischer, *Domkirken i Trondheim. Kirkebygget i Middelalderen*, 2 vols, Trondheim, 1965.

GABORIT-CHOPIN, 1978. Danielle Gaborit-Chopin, *Ivoires du Moyen Age*, Fribourg, 1978, pp. 113–14 (illus. 164), 116 (illus. 168), 200 (cat 164), 201 (cat. 168).

GAMER, 1954. Helena M. Gamer, The earliest evidence of Chess in western literature: the Einsiedeln verses, in *Speculum*, XXIX, 1954, pp. 734–50.

GOLDSCHMIDT, III, 1923; IV, 1926. Adolf Goldschmidt, *Die Elfenbeinskulpturen aus der romanischen Zeit*, III, Berlin, 1923, nos 142–3, pl. XLIX; IV, Berlin, 1926, pp. 4–8; nos 182–239, pls LXIV–LXIX.

GREYGOOSE, 1979. Frank Greygoose, *Chessmen*, Newton Abbot, 1979, illus. 33–4.

HESLOP, 1980. Sandy Heslop, review of Taylor, 1978, in *Journal of the British Archaeological Association*, CXXXIII, 1980, pp. 108–9.

HOHLER, 1989. Erla Bergendahl Hohler, Norwegian Stave Church Carving: an Introduction, in *Arte Medievale*, II Serie, Anno III, n.l, 1989, pp. 77–115.

KITZINGER, 1940. Ernst Kitzinger, *Early Medieval Art in the British Museum*, London, 1940, p. 83, pl. 41A.

KLUGE-PINSKER, 1991. Antje Kluge-Pinsker, *Schach und Trictrac. Zeugnisse mittelalterlicher Spielfreude in Salischer Zeit*, Publikationen zur Ausstellung 'Die Salier und ihr Reich' veranstaltet vom Land Rheinland-Pfalz in Speyer, 1991, Römisch-Germanisches Zentralmuseum, Monographien Bd. 30, Sigmaringen, 1991.

LAING, 1833 (1857). David Laing, A Brief Notice of the small Figure cut in Ivory, supposed by Pennant to represent the King of Scotland in his Coronation Chair, and which was discovered in Dunstaffnage Castle, in *Archaeologia Scotica*, IV, Part III, 1857, pp. 366–9 (paper read to the Society of Antiquaries of Scotland, 11 March 1833).

LASKO, 1960–1961. Peter Lasko, A Romanesque ivory carving, in *British Museum Quarterly*, XXIII, 1960–1961, pp. 12–16, pls. 8–10.

LASKO, 1972. Peter Lasko, *Ars Sacra 800–1200*, Pelican History of Art, Harmondsworth, 1972, pp. 236–7, 310, pls 277–8.

LASKO, 1984. Peter Lasko, in *English Romanesque Art 1066–1200*, catalogue of the Arts Council of Great Britain exhibition, Hayward Gallery, London, 1984, pp. 72, 227 (nos 211–12).

LIDDELL, 1938. Donald M. Liddell, *Chessmen*, London, 1938, partic. pp. 14, 136–42, illus.

LIEBGOTT, 1985. Niels-Knud Liebgott, *Elfenben – fra Danmarks Middelalder*, Nationalmuseet, Copenhagen, 1985, pp. 27 (fig. 17), 30 (figs 21–2).

LINDAHL, 1980. Fritze Lindahl, Spilleldenskab, in *Hikuin*, 6, 1980, pp. 153–62.

LINDAHL, 1992–1993. Fritze Lindahl, in *From Viking to Crusader. The Scandinavians and Europe 800–1200*, Catalogue of the 22nd Council of Europe Exhibition, Paris-Berlin-Copenhagen, 1992–1993, pp. 388 (Cat. no. 606), 390 (Cat. no. 612).

LONGHURST, 1926. M.H. Longhurst, *English Ivories*, London, 1926, pp. 34, 96–7 (no. XLI).

Ed. MACDONALD, 1967. ed. Dr Macdonald of Gisla, *Tales and traditions of the Lews* (sic), Stornoway, 1967.

MACGREGOR, 1985. Arthur MacGregor, *Bone Antler Ivory and Horn. The Technology of Skeletal Materials since the Roman Period*, London/Sydney, 1985, pp. 139–40 (fig. 74).

MCLEES and EKROLL, 1990. Christopher McLees, Øystein Ekroll, A drawing of a medieval ivory chess piece from the 12th-century church of St. Olav, Trondheim, Norway, in *Medieval Archaeology*, XXXIV, 1990, pp. 151–4, fig. 3.

MACLEOD, 1833 (1845). *The New Statistical Account of Scotland, Vol. XIV, Inverness – Ross and Cromarty*, Edinburgh/London, 1845, p. 153 (Island of Lewis, Parish of Uig, by the Rev. Alexander Macleod, Minister, dated 1833).

MADDEN, 1832. Frederic Madden, Historical Remarks on the introduction of the game of Chess into Europe, and on the ancient Chessmen discovered in the Isle of Lewis, in *Archaeologia*, XXIV, 1832, pp. 203–91.

MANN, 1977. Vivian B. Mann, *Romanesque Ivory Tablemen*, Ph.D. thesis, New York University, October 1977 (University Microfilms International, Ann Arbor, Michigan 78-8544), pp. 123–6.

MASKELL, 1905. Alfred Maskell, *Ivories*, London, 1905, pp. 313–19, pl. LXVIII–LXIX.

MISCELLANEA GRAPHICA, 1857. *Miscellanea Graphica: Representations of Ancient, Medieval and Renaissance Remains in the possession of Lord Londesborough*. Drawn, engraved and described by Frederick W. Fairholt, F.S.A. The historical introduction by Thomas Wright, M.A., F.S.A., p. 10, pl. VIII (2pp: text).

MÜLLER, 1995. Markus Müller, in *Heinrich der Löwe und seine Zeit. Herrschaft und Repräsentation der Welfen 1125–1235*, catalogue of exhibition, Braunschweig, 1995, Vol. I (Katalog), München, 1995, pp. 110–12 (No. B25).

MURRAY, 1913. H. J. R. Murray, *A History of Chess*, Oxford, 1913.

PASTOUREAU, 1990(a). Michel Pastoureau, *Pièces d'Échecs*, catalogue of exhibition, Cabinet des médailles et antiques, Bibliothèque Nationale, Paris, 1990.

PASTOUREAU, 1990(b). Michel Pastoureau, *L'Échiquier de Charlemagne. Un jeu pour ne pas jouer*, Paris, 1990.

P.S.A. Scot., 1859. Presentation by A. W. Franks of plaster-casts of five of the Lewis chessmen to the Society of Antiquaries of Scotland, in *P.S.A.Scot.*, II, 1859, p. 345 (meeting 16 February 1857).

P.S.A. Scot., 1888–1889. Purchases for the Museum of the Society of Antiquaries of Scotland, in *P.S.A.Scot.*, XXIII, 1888–1889, pp. 9–14.

PRIOR and GARDNER, 1912. Edward S. Prior, Arthur Gardner, *An Account of Medieval Figure-Sculpture in England*, Cambridge, 1912, p. 172, fig. 154.

R.C.A.H.M.C. Scot., 1928. R.C.A.H.M.C. Scot., Ninth Report, with Inventory of Monuments and Constructions in the Outer Hebrides, Skye and the Small Isles, Edinburgh, 1928, pp. XLIII, 23–4 (report of 8 July 1914).

RIDDLER, 1995. Ian D.Riddler, Anglo-Norman Chess, in ed. A. J. de Voogt, *New Approaches to Board Games Research: Asian Origins and Future Perspectives*, International Institute for Asian Studies Working Papers Series 3, Leiden, 1995, pp. 99–110.

ROESDAHL, 1995. Else Roesdahl, *Hvalrostand elfenben og nordboerne i Grønland*, Odense Universitetsforlag, 1995.

STRATFORD, 1992–1993. Neil Stratford, in *From Viking to Crusader. The Scandinavians and Europe 800–1200*, Catalogue of the 22nd Council of Europe Exhibition, Paris–Berlin–Copenhagen, 1992–1993, pp. 390–1 (nos 611, 614–15).

TAYLOR, 1978 (1995). Michael Taylor, *The Lewis Chessmen*, British Museum, 1978 (Tenth Impression, British Museum Press, 1995).

THOMAS, 1863. Captain F. W. L. Thomas, Notes on the Lewis Chessmen, in *P.S.A.Scot.*, IV, 1860–1862 (1863), pp. 411–13.

TRONZO, 1977. William L. Tronzo, Moral Hieroglyphs: Chess and Dice at San Savino in Piacenza, in *Gesta*, XVI/2, 1977, pp. 15–26.

WAHLÖÖ, 1992–1993. Claes Wahlöö, in *From Viking to Crusader. The Scandinavians and Europe 800–1200*, Catalogue of the 22nd Council of Europe Exhibition, Paris-Berlin-Copenhagen, 1992–1993, p. 390 (Cat. no. 613).

WICHMANN, 1960 (1964). Hans und Siegfried Wichmann, *Schach. Ursprung und Wandlung der Spielfigur in zwölf Jahrhunderten*, Munich, 1960, pp. 290–91 (nos 41–3) (English translation, *Chess. The story of chesspieces from antiquity to modern times*, London, 1964).

WILKINSON, 1943. Charles K. Wilkinson, Chessmen and Chess, in *The Metropolitan Museum of Art Bulletin*, Vol. I, no. 9, 1943, pp. 271–9.

WILSON, 1851. Daniel Wilson, *The Archaeology and Prehistoric Annals of Scotland*, Edinburgh, 1851.

Concordance of Numbers

British Museum Iv. Cat.	reg. nos MLA 1831,11-1,	Madden	Goldschmidt
78	1	King no. 1	184
79	2	" " 2	187
80	3	" " 4	186
81	4	" " 5	185
82	5	" " 3	182
83	6	" " 6	183
84	7	Queen no. 1	188
85	8	" " 5	192
86	9	" " 4	191
87	10	" " 3	189
88	11	" " 2	190
89	12	Bishop no.2	197
90	13	" " 1	200
91	14	" " 3	203
92	15	" " 4	201
93	16	" " 5	204
94	17	" " 11(?)*	202
95	18	" " 8(?)*	198
96	19	" " 12(?)*	195
97	20	" " 13(?)*	194
98	21	" " 7	199
99	22	" " 9	193
100	23	" " 6	196
101	24	" " 10(?)*	-- **
102	25	Knight no.13	205
103	26	" " 10	215
104	27	" " 9	214
105	28	" " 11	211
106	29	" " 12	210
107	30	" " 8	209
108	31	" " 7	217
109	32	" " 14	208
110	33	" " 5	213
111	34	" " 6	212
112	35	" " 3	207
113	36	" " 4	206
114	37	" " 2	216
115	38	" " 1	218
116	39	Warder no. 2	224
117	40	" " 3	226
118	41	" " 1	228
119	42	" " 4	227
120	43	" " 5	225
121	44	" " 9	223

Iv. Cat.	MLA 1831,11-1,	Madden	Goldschmidt
122	45	" " 10	219
123	46	" " 7	221
124	47	" " 6	220
125	48	" " 8	222
126	49	Pawn no. 1	Goldschmidt does
127	50	" " 6	not illustrate any of
128	51	" " 5	the pawns or
129	52	Pawns 2–3–4	draughtsmen
130	53		
131	54		
132	55	Pawn no. 7	
133	56	Pawns nos 8–19	
134	57	correspond to	
135	58	Iv. Cat. 133–44 but	
136	59	are not identified by	
137	60	Madden.	
138	61		
139	62		
140	63		
141	64		
142	65		
143	66		
144	67		
145 (belt-buckle)	68	not numbered,	
146–159	69–82	but illus. pl. XLVIII,	
(draughtsmen)		fig. 9	

* 5 of the 13 bishops are not 100% identifiable from Madden's text, but the proposed numbers are probably correct.

** Goldschmidt does not illustrate or number one of the 13 bishops (Iv. Cat. 101)

Edinburgh, National Museums of Scotland
Nos NS19-29 (Cat. NMAS, 1892, pp. 374–5). Goldschmidt

(King)	A.NS 19	229
(")	" " 20	230
(Queen)	" " 21	233
(")	" " 22	232
(")	" " 23	231
(Bishop)	" " 24	236
(")	" " 25	234
(")	" " 26	235
(Knight)	" " 27	237
(Warder)	" " 28	238
(")	" " 29	239